COUNTRY STORE
—— TO ——
CORNER MARKET
ALABAMA, LOUISIANA, AND MISSISSIPPI

RAYMOND BIAL

AMERICA
THROUGH TIME®
ADDING COLOR TO AMERICAN HISTORY

Credits

These images appear Courtesy of the Library of Congress, Prints& Photographs Division; Andrew D. Lytle Collection, Louisiana and Lower Mississippi Valley Collections, LSU Libraries; East Baton Rouge Parish Library; the State Library of Louisiana Historic Photograph Collection; the Mississippi Digital Library; the Alabama Department of Archives and History Digital Collections; Historic New Orleans Collection, Charles L. Franck, Franck-Bertacci Photographers Collection; Delta State University Archives and Museum; Chinese Grocery Store Collection; Mississippi Digital Library); University of New Orleans Library; Hogan Jazz Archive, Special Collections, Howard-Tilton Memorial Library, Tulane University. These contributing institutions are indicated with each of the photographs on the following pages.

America Through Time is an imprint of Fonthill Media LLC
www.through-time.com
office@through-time.com

Published by Arcadia Publishing by arrangement with Fonthill Media LLC
For all general information, please contact Arcadia Publishing:
Telephone: 843-853-2070
Fax: 843-853-0044
E-mail: sales@arcadiapublishing.com
For customer service and orders:
Toll-Free 1-888-313-2665

www.arcadiapublishing.com

First published 2021

Copyright © Raymond Bial 2021

ISBN 978-1-63499-311-1

Typeset in Mrs Eaves XL Serif Narrow
Printed and bound in England

CONTENTS

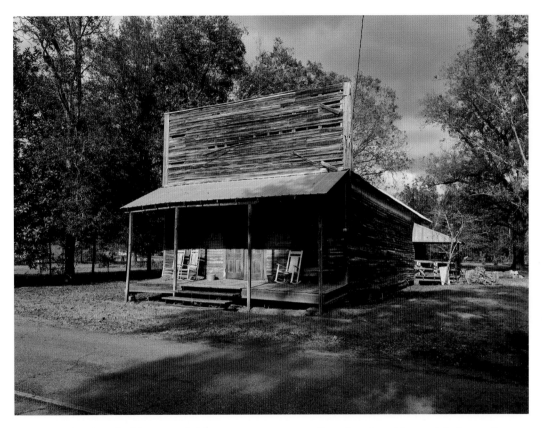

This abandoned cabin was probably once a country store. Along the edge of the road, in Learned, Mississippi, it sports a facade and porch. The corrugated tin roof and clapboard siding are also giveaways that this was a quintessential country store. [*Library of Congress*]

INTRODUCTION

Country stores and corner markets fascinate anyone who appreciates the charm of these stores and memories of days gone by. One cannot help but appreciate the warmth, and a little humor too. It is no surprise that small stores in the country and markets in cities are at the heart of American social and cultural life—of families, friends, and neighbors along country roads and on city streets. Many of us grew up with these stores, beginning with frequent trips to the local market with parents or grandparents. Or we have heard stories of old times.

The most familiar of everyday places, country stores and corner markets have enjoyed a long, colorful history in shaping the culture and social life of America, from the early colonies to the Western frontier, as settlers made their way west eventually to California and Oregon, and on to Alaska.

Through vivid photographs, this book recounts the history of these lively enterprises in the Deep South. It is a distinct region, ranging from clapboard shacks in Cotton Country; improvised groceries in the marshes and swamps of Cajun Country; and the bustling French Market in New Orleans. The photographs in *Country Store to Corner Market: Alabama, Louisiana, and Mississippi* are as varied and vibrant as the region and races of the people who have made the Deep South their home for generations.

The book emphasizes common people—proprietors, clerks, customers, and those who have just stopped by to visit with friends. The local store became the gathering place for townspeople, farmers, and field hands. People often sat around the potbelly stove to gossip, play cards, and idle away a rainy day.

Early storekeepers carried "dry goods" that kept well. These included coffee, flour, sugar, crackers, spices, pickles, vinegar, and molasses that people could not easily make for themselves. Storekeepers lined their shelves from floor to ceiling and piled the counter with these staples, and perhaps a jar of penny candy on the counter. Staples were stacked in the middle of the floor; stored in barrels, boxes and bins; and hung on hooks from the tin ceiling. All these items were stocked in bulk, so that the storekeeper measured or weighed the desired amount and poured it into bag for customers.

Over time, dry goods stores evolved into general stores that also stocked tinned foods such as sardines, oysters, peaches, and other "fancy groceries." General stores also carried appealing

merchandise—everything from bolts of cloth to farm tools. Farmers and townspeople stopped by to purchase necessities such as hardware, tools, glass, clothing, and medicines. The proprietor could mail order items such as farm equipment, cook stoves, and sewing machines for customers. Country stores often housed the local post office.

The bustling store sold merchandise for "cash money," offered credit to tenant farmers and sharecroppers against their harvest, or traded for fresh eggs, butter, vegetables, and fruit. Storekeepers then sold this fresh food to townspeople.

As towns grew into cities, corner stores popped up in neighborhoods. Like their country cousins, they stocked flour, sugar, syrup, salt, tea, coffee, tobacco, spices, dried fruit, and other items that could not be made at home. These "mom-and-pop" groceries served every neighborhood in every city from the late nineteenth into the twentieth centuries. Many stores reflected the immigrant culture of the neighborhood—German, Irish, Polish, Italian, Jewish, Scandinavian, and Chinese. These grocers carried foods from the "old country" and did business in the native language of their customers.

By the early years of the twentieth century, small groceries dotted every neighborhood in every city. Families had no refrigeration other than an icebox, and housewives had to shop for fresh food every day or two. Unless there was a streetcar line nearby, people had to walk to a grocery store that had to be located near their homes. Each of these stores had a few hundred regular customers. Large cities like New Orleans also opened markets where vendors offered an abundance of fresh vegetables and fruit.

After World War I, the rise of chain stores, notably the Great Atlantic and Pacific Tea Company (A&P) and Kroger, threatened mom-and-pop groceries—and a way of life. People could now drive a new invention—the automobile—to supermarkets beyond their neighborhood. These chain stores bought large quantities of products at low prices, often directly from manufacturers instead of wholesalers. Mom-and-pop grocery stores were forced out of business.

At the time, stores were full service. A clerk behind the counter fetched and packaged the items requested by a shopper. However, on September 9, 1916, Clarence Saunders opened a Piggly Wiggly grocery in Memphis, Tennessee, which was the first "self-serving store." Shoppers entered this modern store through turnstiles and strolled down narrow aisles through a maze of shelves stacked with groceries. Customers selected their goods and made their way back to the cashiers at the front of the store, who replaced full-service clerks. The Piggly Wiggly concept grew rapidly through the Great Depression. By the late 1930s, there were over 2,600 self-service groceries nationwide—many in the Deep South. From there, groceries evolved into the supermarkets of today.

This book offers a sampler of sorts of the early stores and markets of the Deep South. Laid out chronologically, with captions, the images reveal the heartbreak, hope, and humor of people struggling to scratch out a living for themselves or enjoy the high life of the big city. I sorted through thousands of historic photographs and loved every moment of research and writing. I believe the book offers a fascinating look at those who came before us. I hope that you also like *Country Store to Corner Market: Alabama, Louisiana, and Mississippi* as much as I enjoyed working on this book.

1

YEARS OF GROWTH: LATE 1800s TO 1930s

Long before the invention of photography, the Deep South was a bustling region of plantations and farms along with shipping and trade, notably at the port city of New Orleans. Fresh vegetables and fruits also came to be sold there in the French Market. However, with the invention of the cotton gin, "King Cotton" came to rule the day. The cotton was picked by hand, bagged in cloth sacks, and pulled along on the backs of men, women, and children held in slavery. After liberation, blacks became field hands, working alongside whites who already endured hardscrabble lives. Vast fields of white were picked clean and the fluffy bolls were packed into huge bales.

Here, the country stores served the poorest of the poor. There was a strict code of separation with "No Colored" or "Colored Only" signs in the country while New Orleans was enriched with a blend of races and cultures. There, people shopped at neighborhood stores and the French Market. Among these dominant industries of cotton plantations and shipping were small farmers, black and white, who became tenant farmers, sharecroppers, and field hands. Everyone struggled to rise above poverty and racism. It would a century later, however, before African Americans began to win the fight for civil rights.

For now, blacks and whites in both town and country worked long hours to earn enough "cash money" for food, clothing, and shelter. Times were hard and then came the Great Depression.

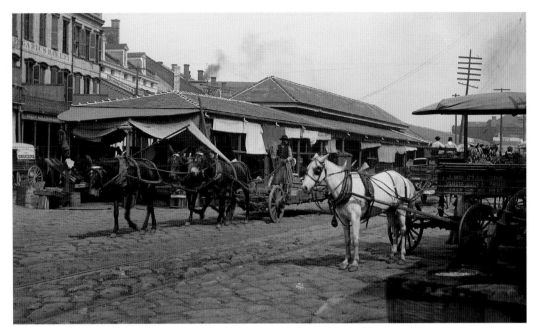

Noted artist William Henry Jackson took this photograph of the old French Market, New Orleans, between 1880 and 1897. The image depicts horses and mules drawing carts and wagons along the cobblestone street with the French Market prominent in the background. [*Library of Congress*]

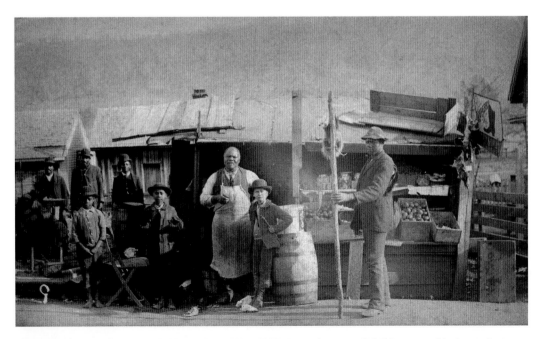

This portrait was taken by O. W. Chase about 1880-1889. Several men and children stand in front of a grocery store and shoe repair shop in Fort Payne, Alabama. The man in the center, wearing an apron, is the owner, and the man on the right is holding a stick with a possum attached. [*Alabama Archives*]

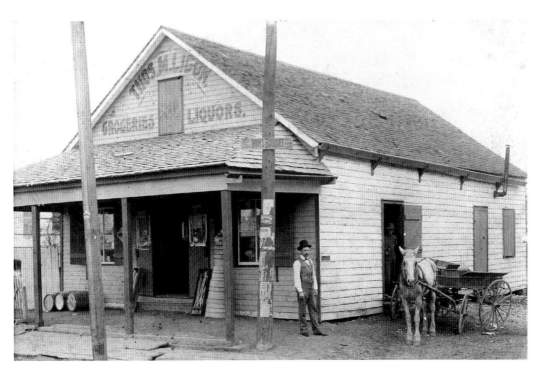

Thomas M. Ligon Grocery was located on the southwest corner of Main and Dufrocq streets in Baton Rouge, Louisiana. Shown here in 1897 are Mr. Ligon with his mare, "Eagle," and delivery boy, Sol Tucker, standing in the side doorway. [*Image courtesy of the East Baton Rouge Parish Library*]

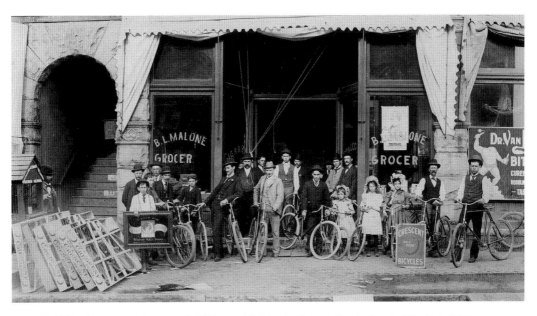

In 1898, this group of men and children with bicycles is standing in front of the B. L. Malone grocery store, which was probably located in New Decatur, Alabama. They are showing off a shipment of shiny new bicycles. A sign on the right advertises for "Crescent 'Sky High' Bicycles" and "Ride a Crescent Bicycle." [*Alabama Archives*]

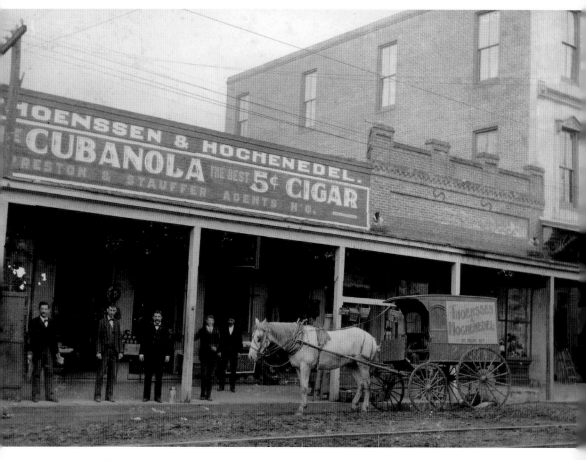

Thoenssen & Hochenedel, which sold groceries, tobacco, and liquors, was located at 306 Main Street, in Baton Rouge. Andrew David Lytle took this photograph at the turn of the century. The proprietor and clerks, along with a horse and delivery wagon, are in front of the enterprise. [*LSU Libraries*]

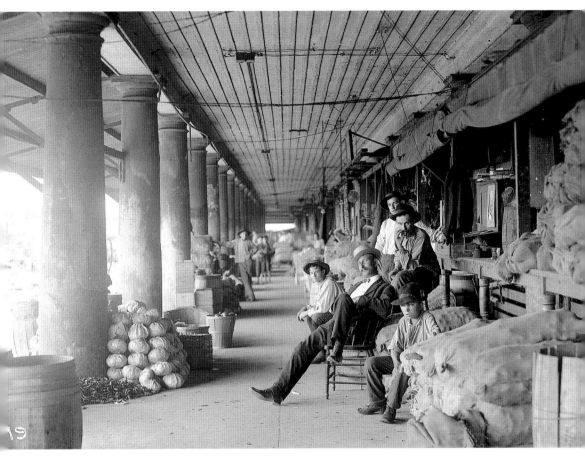

Photographed by Frank B. Moore, this image captures a scene in an interior of the French Market in New Orleans about 1900. There are stately columns along the gallery on the left. On the right, three men and two boys are relaxing amid sacks of flour, sugar, or other dry goods. [*University of New Orleans Library*]

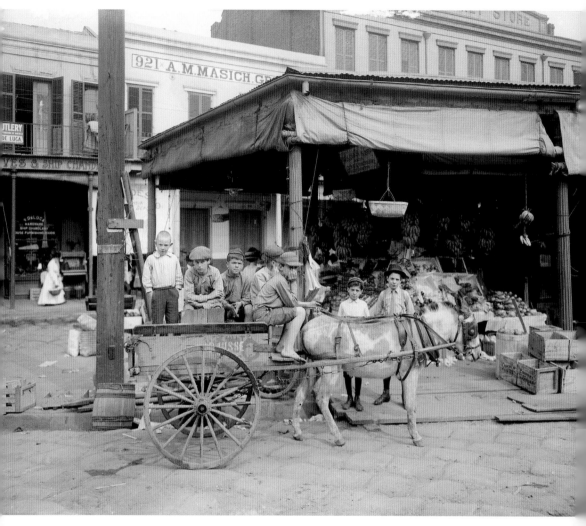

This boy paused at a corner of the French Market in New Orleans about 1900-1910. The able young man is holding the reins as he perches on a two-wheeled cart drawn by a single horse. Several other boys have gathered around the cart with a variety of fruit and vegetables in the background. [*Library of Congress*]

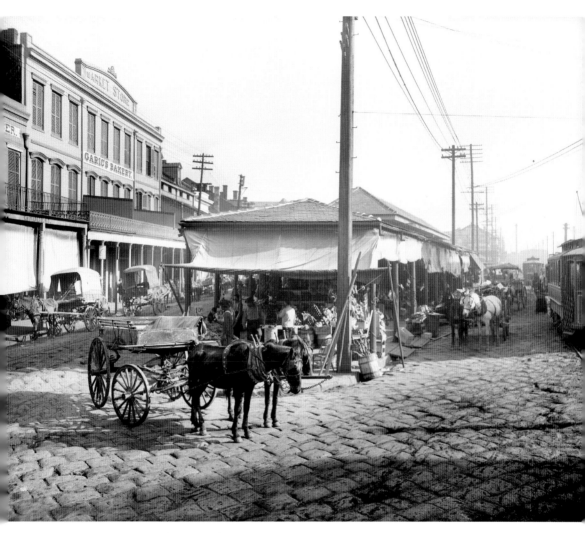

This early photograph (about 1906) depicts the French Market in New Orleans, Louisiana. Horse-drawn wagons and carts are gathered on the cobblestone street next to the market. To the right, streetcars are moving down the line and to the left are a grocery and bakery in the Market Store building across the street. [*Library of Congress*]

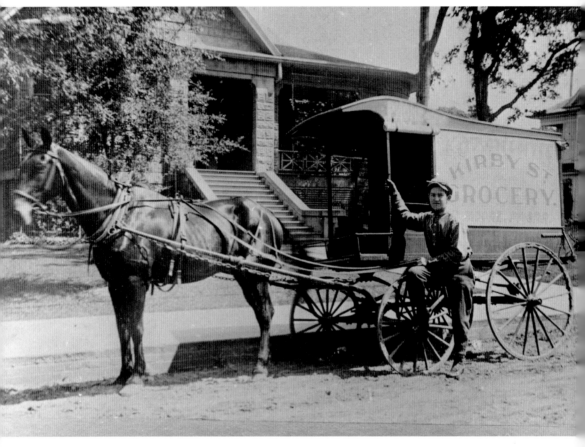

The delivery boy for the Kirby Street grocery stops for a photograph with his horse and wagon. Taken on the corner of Hodges and Kirby streets in Lake Charles, Louisiana, about 1910, the photograph offers a charming look deep into the past. [*McNeese State University*]

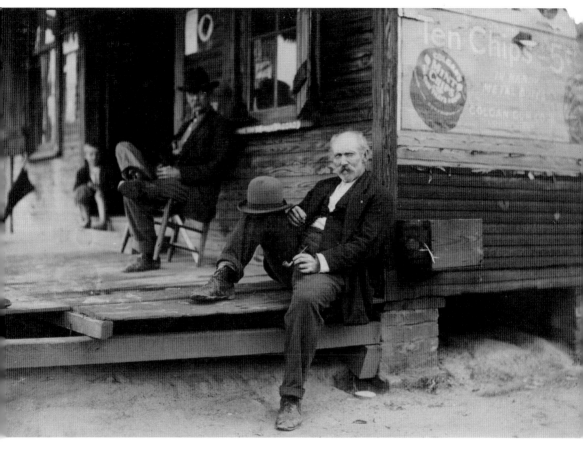

Entitled "The Dependent Widower," this photograph by noted social reformer Lewis Wickes Hine was taken in Meridian, Mississippi, in April 1911. The image portrays an old man who is an unemployed widower dependent on a pension. He is sitting on the side of the porch of a general store. [*Library of Congress*]

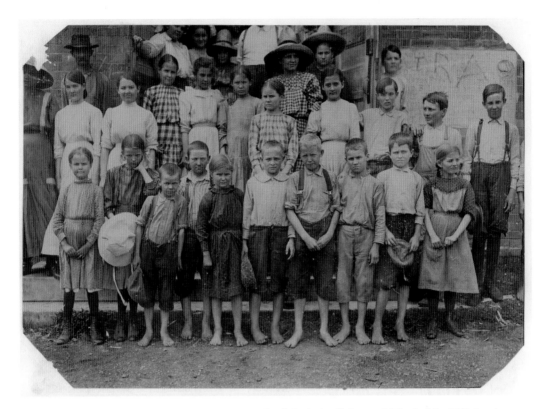

These children are the youngest workers in Magnolia (Mississippi) Cotton Mills. In May 1911, Lewis Wickes Hine made this heart-breaking photograph of the children who had to work long hours to help their families with groceries. [*Library of Congress*]

Opposite page:

Above: Lewis Wickes Hine photographed this delivery boy in October 1914. Boys often worked for grocery stores, and later for drug stores and department stores. Hungry and poor, eleven-year-old Willie Roberts would take any work that came his way. [*Library of Congress*]

Below: In October 1914, this ten-year-old was making deliveries for a small department store in Opelika, Alabama. Astride his bicycle with no chain guard, he has rolled up his pants. He is barefoot, perhaps for a better grip on the peddles. In any case, he was ready for action when Lewis Wickes Hine photographed him. [*Library of Congress*]

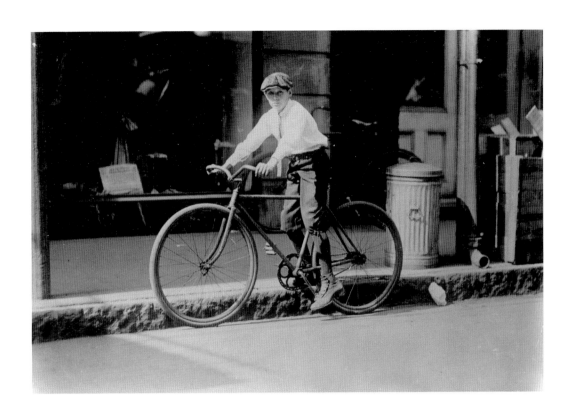

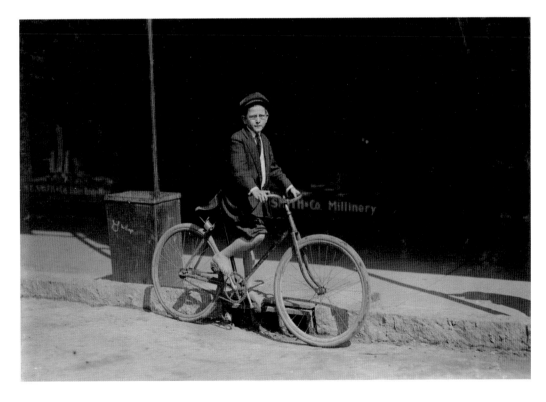

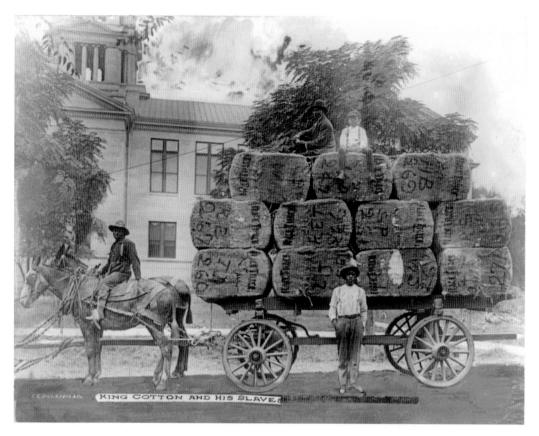

KING COTTON AND HIS SLAVES

In this photograph, three African-American men and a boy posed with their horse-drawn wagon loaded high with bales of handpicked cotton in front of the Leflore County courthouse in Greenwood, Mississippi. It is around 1920 and the photograph is captioned, "King Cotton and his slaves." [*Library of Congress*]

Opposite page:

This photograph depicts an African-American woman carrying a basket of groceries on her head. Walking along a dusty road, she is returning home from the country store in Montgomery, Alabama. It is October 1927, but this talent from Africa had already been passed down through generations of women. [*Alabama Archives*]

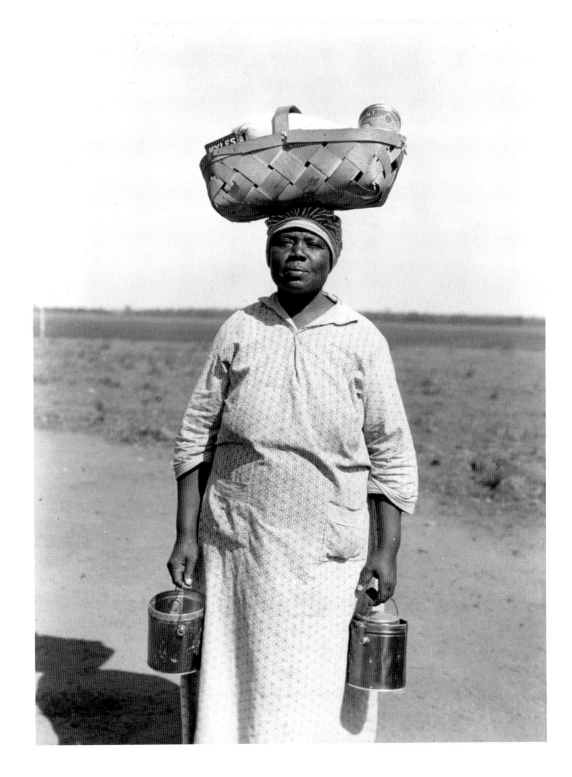

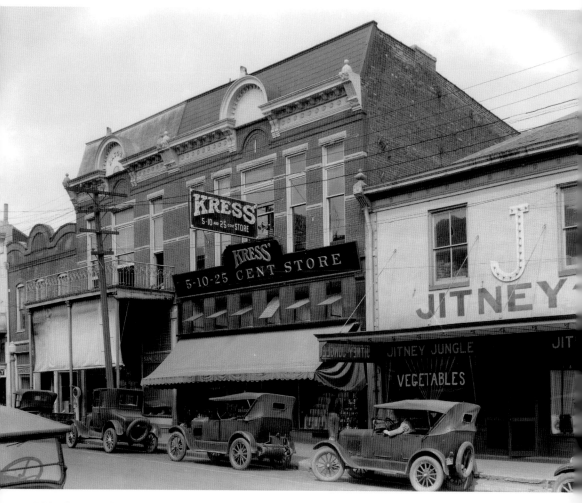

This photograph of the Kress 10 and 25 Cent Store includes other popular stores and signs, notably Jitney Jungle, Sam Dreyfus, DeMarco's, and a Piggly Wiggly. Taken in downtown Natchez, Mississippi, the photograph portrays a bustling town around 1925. [*LSU Libraries*]

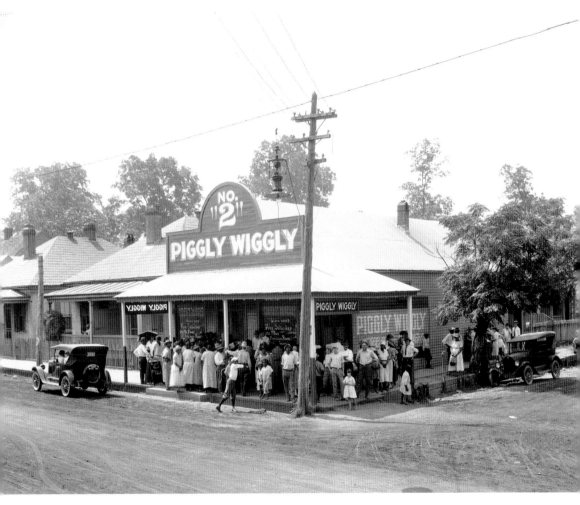

Taken about 1925, this photograph depicts Piggly Wiggly No. 2 in Natchez, Mississippi. A crowd has gathered on the porch of the store, perhaps for a big sale. Many of the people are looking back at the camera, hoping to literally get into the picture. [*LSU Libraries*]

This photograph depicts a neat row of shops and stores, including Moon Chinese grocery in Cleveland, Mississippi, in the 1920s. Judging from all the pedestrians and parked automobiles, this was a busy street, especially for a small town. [*Delta State University Archives and Museum*]

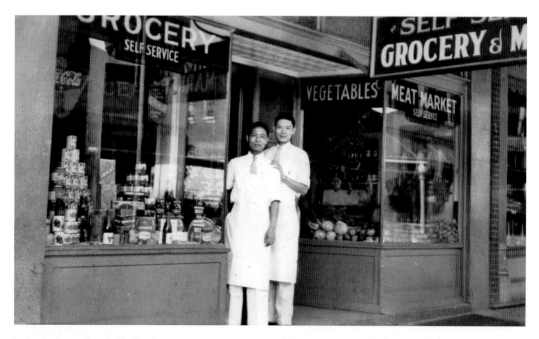

This photograph outside the family store captures a touching moment in the lives of a father and son in Natchez, Mississippi. Canned goods and fresh fruit and vegetables are displayed in the windows of the store which touts itself as "self-service." [*Delta State University Archives and Museum*]

2

GREAT DEPRESSION IN THE DEEP SOUTH

In the 1930s, Alabama, Louisiana, and Mississippi plunged into the depths into the Great Depression, like the rest of the country. The crisis was worsened in the Deep South for sharecroppers and tenant farmers, who were already "dirt poor." As always, people worked hard to put food on the table, keep a roof overhead, and make the most of their lives. Everyone struggled to get by. It was no better in towns and cities where men and women lost their jobs and were evicted from shotgun houses and apartments when they couldn't pay the rent. With rags on their backs and bare feet, thousands of poor folk, country and city, were already gaunt with hunger. Now they were homeless, too.

The plight of Americans—children, women, men, families—during the Great Depression was chronicled in a collection of amazing photographs by a group of brilliant young artists who worked for the Farm Security Administration (FSA) in the Department of Agriculture. Many of these fine photographs are included in this book. Much of the FSA work in the 1930s captured the heartbreak and hope and a little humor at times, reminding us that the human spirit is resilient.

In the world war that followed in the 1940s, Americans again rose to the occasion. Working together, from all races and all locales, they showed the world the ingenuity and raw strength of a people who would never be defeated.

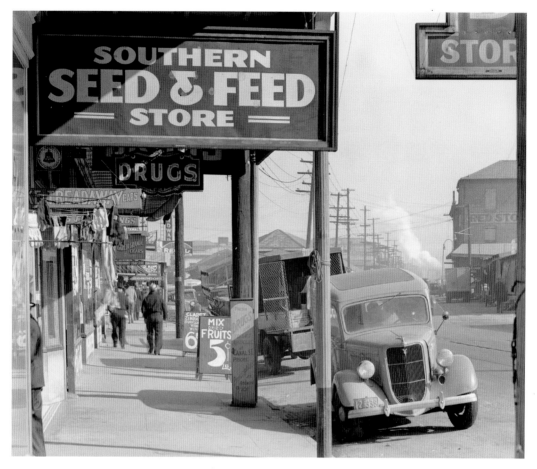

Walker Evans photographed this street near the French Market and the waterfront in New Orleans as it appeared in December 1935. Parked along the curb are a stylish automobile and a truck, which is delivering bacon and lard for a grocery (not shown) on the left of the sidewalk. [*Library of Congress*]

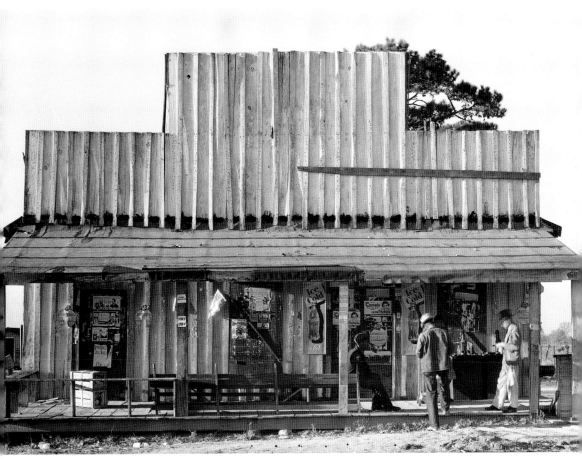

In January 1936, Walker Evans photographed this general store in the vicinity of Selma, Dallas County, Alabama. Like many country stores, it has a porch and false front. A few people have stopped by and shopped, then gathered on the porch to visit for a while. [*Library of Congress*]

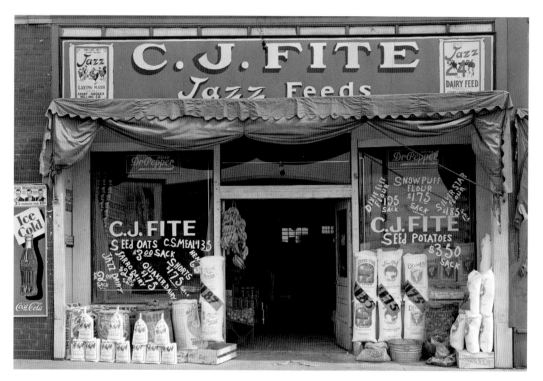

Walker Evans photographed C. J. LaFite Jazz Feed and Seed Store in March 1936. It is the start of the growing season in Alabama, and the store is well stocked with seeds and bulbs. It also carries livestock feeds and groceries for local people. Sacks of flour are displayed outside, and a clump of bananas hangs in the doorway. [*Library of Congress*]

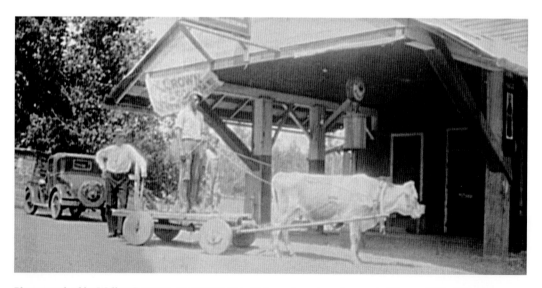

Photographed by Walker Evans in April 1936, this African-American farmer in Dixons Mills, Marengo County, Alabama, has come to town for groceries and feed. Not having a mule, he has hitched his milk cow to a cleverly made wooden wagon, including wheels, pins, and axles. Luckily, unlike many cattle, this cow is quite agreeable. [*Library of Congress*]

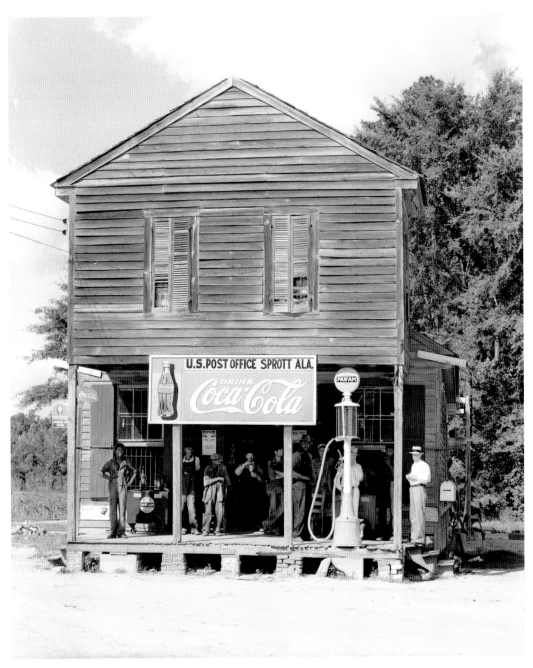

Walker Evans composed this photograph of a country store at a dusty crossroads in the little town of Sprott, Perry County, Alabama. Evans captured this quiet moment when several men gathered around the front porch in the summer 1935 or 1936, probably the latter. [*Library of Congress*]

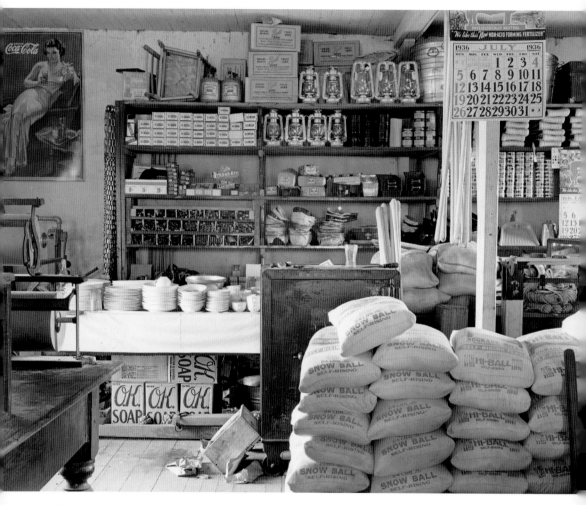

In the summer of 1936, Walker Evans took this photograph of the interior of the general store, also known as a mercantile, in the small town of Moundville, Hale County, Alabama. The still life not only documents the store, but is also a carefully composed work of art. [*Library of Congress*]

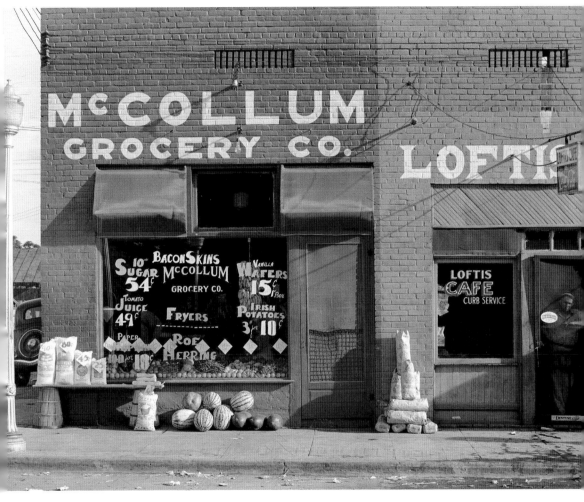

Walker Evans artfully composed this photograph of the front of the McCollum Grocery and Loftus Café in the summer of 1936. Located in Greensboro, Alabama, the store offered a variety of canned goods and fresh produce, along with bacon skins, fryers, and herring. [*Library of Congress*]

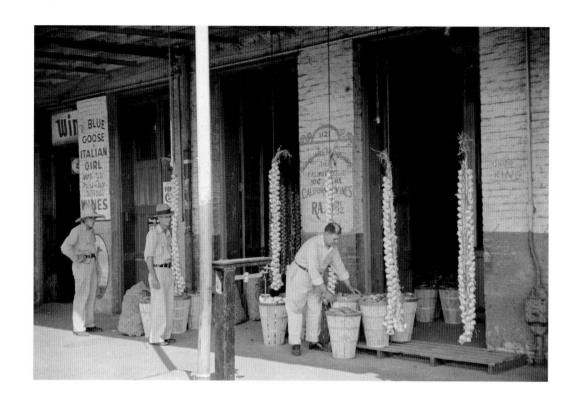

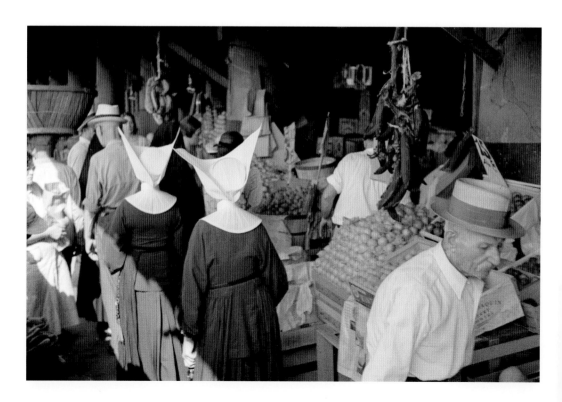

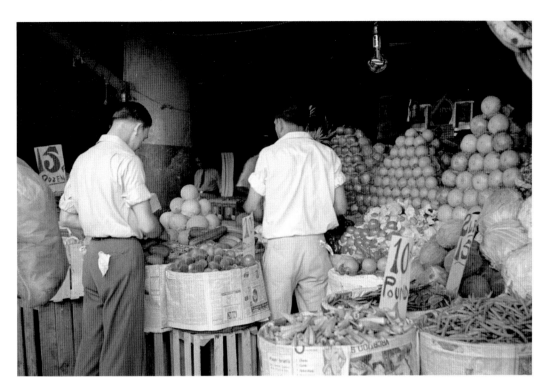

These two young men are carefully looking through the assortment of fresh fruit and vegetables in the French Market in New Orleans. Carl Mydans photographed the shoppers and pyramids of stacked oranges and grapefruit in June 1936. [*Library of Congress*]

Opposite page:

Above: Three men, most likely the proprietor on the right and two workers, are arranging bushel baskets of fresh vegetables at the French Market in New Orleans. Taken in June 1936, this photograph by Carl Mydans includes long strings of garlic and advertisements for fine wines. [*Library of Congress*]

Below: Carl Mydans photographed these shoppers, including two Sisters, who were looking for bargains like everyone else. With habits like angel wings, they sifted through the crowds at the French Market in New Orleans in June 1936. [*Library of Congress*]

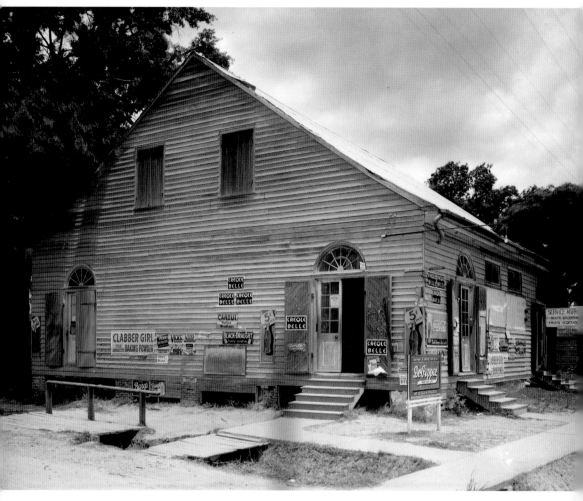

Located in Grand Coteau, St. Landry Parish, Louisiana, Petitin's Store carried goods ranging from Clabber Girl baking powder to D. Pepper soda pop. The store was also plastered with Creole Belle coffee signs. Frances Benjamin Johnston photographed the store in 1938. [*Library of Congress*]

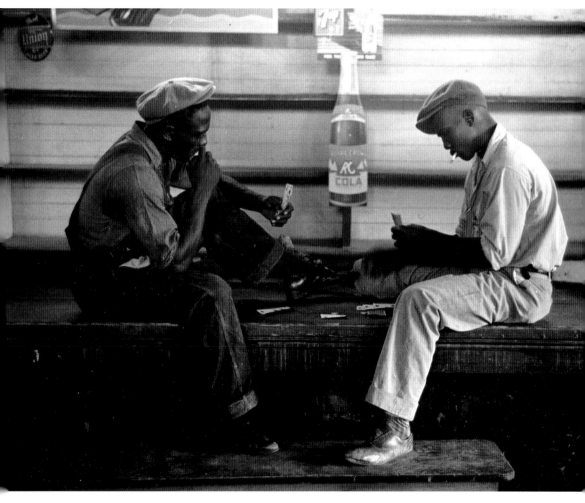

These two men are playing a rummy-style card game called conquian (also known as coon can or colonel) in a country store near the town of Reserve, Louisiana. The forerunner of rummy, coon can was a challenging game that required a good memory. Russell Lee photographed the men, concentrating on their game in September 1938. [*Library of Congress*]

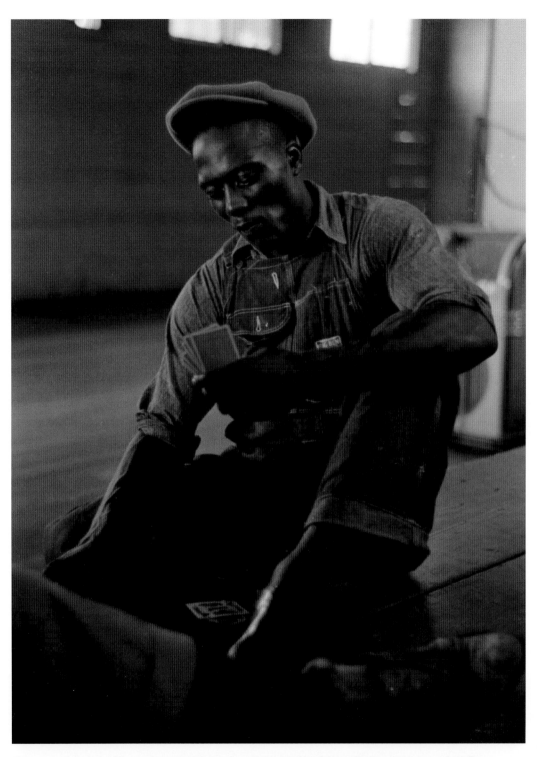

This man is studying his cards in an intense game of conquian (also called coon can or colonel) in a country store near the small town of Reserve, Louisiana. In September 1938, Russell Lee photographed the man deep into this game, which was early version of rummy. [*Library of Congress*]

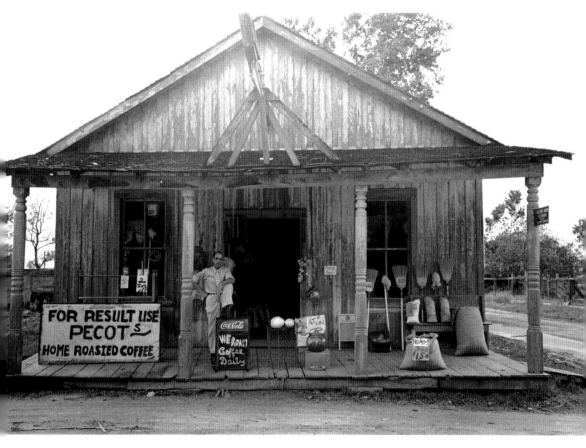

Foot propped on a sign advertising coffee roasted every day, this storekeeper is understandably proud of his enterprise in Jeanerette, Louisiana. The store appears to specialize in coffee, but also carries everything from hominy to brooms. Russell Lee made this photograph in October 1938. [*Library of Congress*]

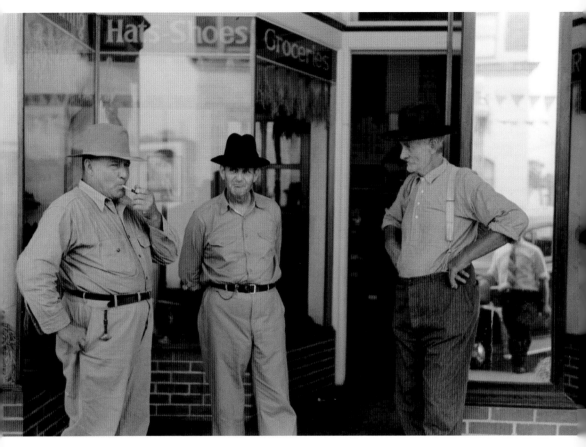

These three farmers are talking in front of an old store in Crowley, Louisiana. The general store includes hats, shoes, and groceries. Photographed by Russell Lee in October 1938, the men are no doubt discussing the harvest and pondering if "the good weather will hold." [*Library of Congress*]

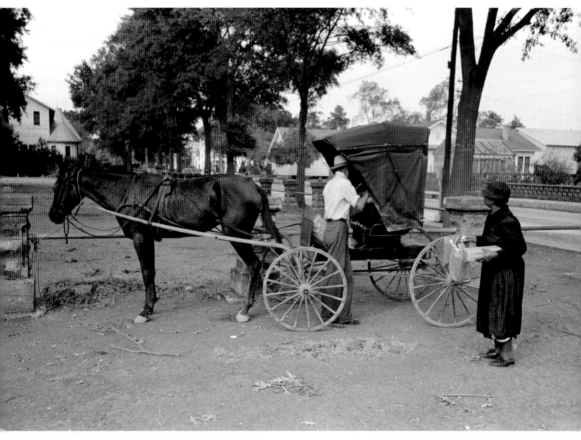

While the missus stands by, this farmer loads groceries into their buggy in Lafayette, Louisiana—in the heart of Cajun country. Going into town was an event for the couple which is probably why they took the buggy that day. Russell Lee photographed them in October 1938. [*Library of Congress*]

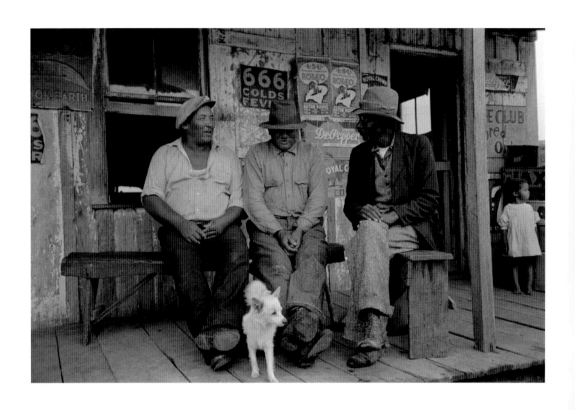

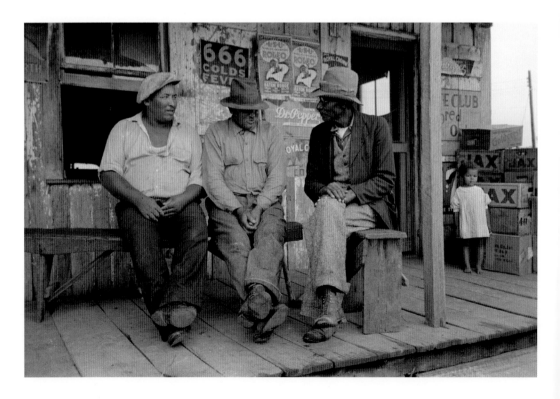

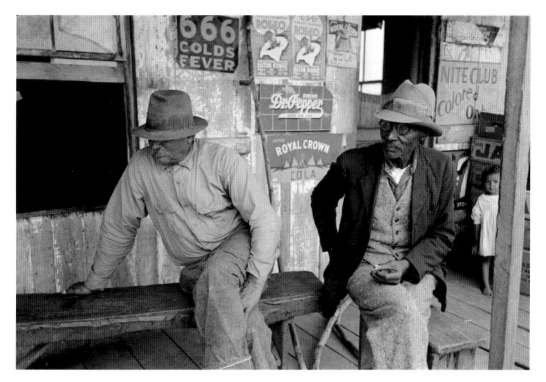

Sitting on the porch of a small store near Jeanerette, Louisiana, these two old men are talking, perhaps swapping a few stories from deep in their past. Taken by Russell Lee in October 1938, the photograph also includes a little girl peeking around a post and signs for soda pop and one that reads, "NITECLUB Colored Only." [*Library of Congress*]

Opposite page:

Above: These three African-American men are talking on the porch of small store near Jeanerette, Louisiana, and enjoying the company of their little dog and a wandering toddler. Russell Lee photographed all of them in one candid moment in October 1938, probably late in the day. [*Library of Congress*]

Below: These three older men are talking on the porch of a small country store near Jeanerette, Louisiana, and somewhat looking after a wandering toddler. It was probably the end of a pleasant day when Russell Lee photographed them in a quiet moment in October 1938. [*Library of Congress*]

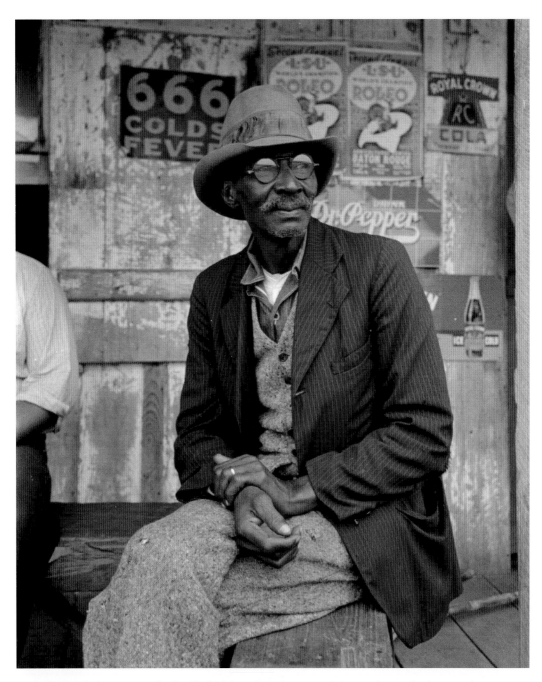

Russell Lee took this portrait of a dignified African-American man sitting on the porch of a general store near the small town of Jeanerette, Louisiana, in October 1938. It is a fine character study showing how the poorest of people respect themselves and expect others to recognize them as such. [*Library of Congress*]

Opposite page: This little girl is posing on the porch of a small store near Jeanerette, Louisiana, next to cases of Jax beer and beneath a sign that reads, "Colored Only." Photographed by Russell Lee in October 1938, she goes barefoot through the summer, like most country children, and maybe through the winter, too. [*Library of Congress*]

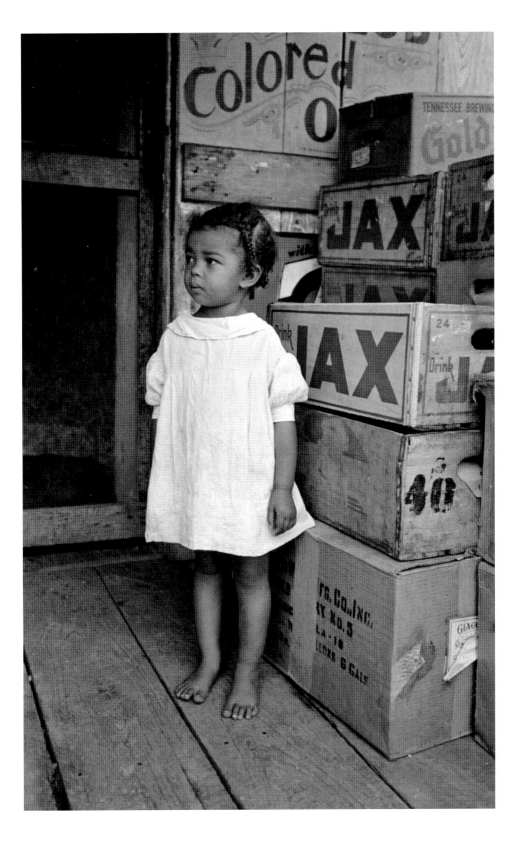

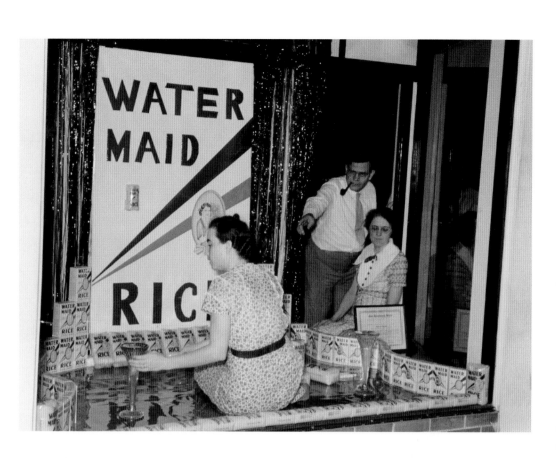

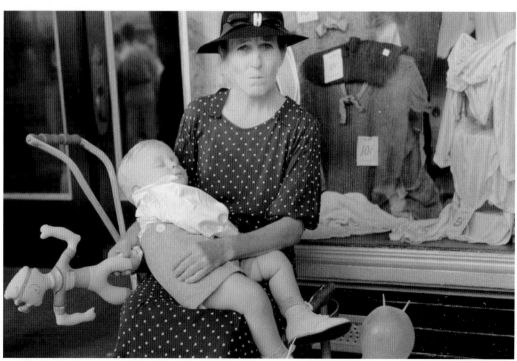

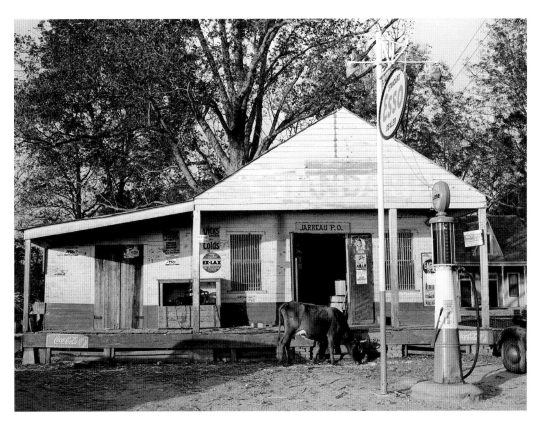

In October 1938, in Jarreau, Pointe Coupee Parish, Louisiana, Russell Lee took this amusing photograph of a general store, gas pumps, and milk cow. The cow is nonchalantly grazing on the sparse grass by the porch enjoying a lifestyle that is as free range as it gets. [*Library of Congress*]

Opposite page:

Above: In October 1938, Russell Lee photographed the storekeeper and clerks of the general store decorating the front window for National Rice Festival in Crowley, Louisiana. One of the clerks with an artistic flair paints a Water Maid rice sign with boxes of rice displayed around her. [*Library of Congress*]

Below: This woman has come to the National Rice Festival and appears none too happy about it, or maybe she just doesn't like to be photographed. At least the baby in her lap is sleeping, as she sits in front of a store in Crowley, Louisiana. In October 1938, Russell Lee made this portrait of her, the child, and a Popeye toy. [*Library of Congress*]

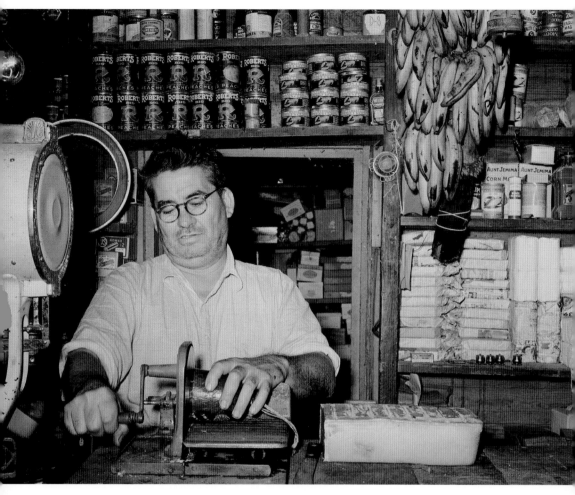

In October 1938, Russell Lee photographed the owner of the general store Jarreau, Pointe Coupee Parish, Louisiana. The sturdy man is slicing baloney with a hand crank on the counter next to him. Bananas hang from the ceiling and canned goods along with other staples line the shelves. [*Library of Congress*]

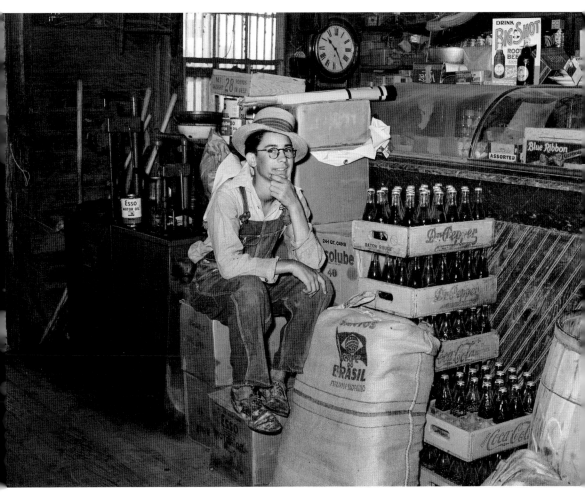

Walker Evans photographed this young farmer in October 1938. He is sitting on a stack of cartons next to wooden crates of soda pop in the general store in Jarreau, Pointe Coupee Parish, Louisiana. The country may be in the depths of a depression, but he was still a happy-go-lucky guy. [*Library of Congress*]

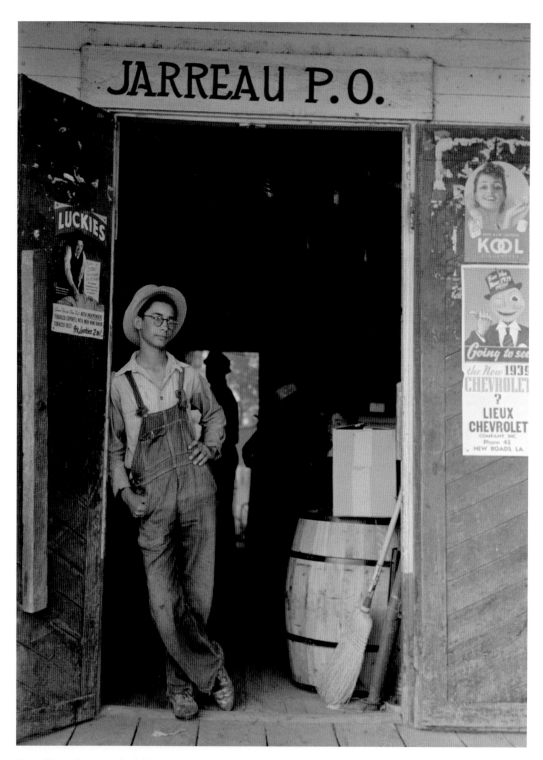

Russell Lee photographed this young man leaning against the doorway of the post office at the general store in Jarreau, Pointe Coupee Parish, Louisiana. It is November 1938 in the Great Depression, but he smiles back at the camera. Life never feels too bleak when one is young and confident. [*Library of Congress*]

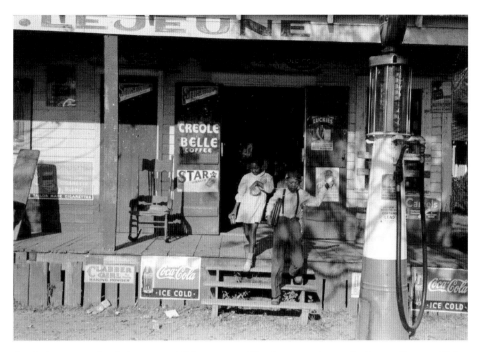

On their way to school, these two children stopped by the general store in the small town of Mix, Louisiana. They probably bought their lunches there, which they are now carrying in hands. Russell Lee took this charming photograph of the energetic children in November 1938. [*Library of Congress*]

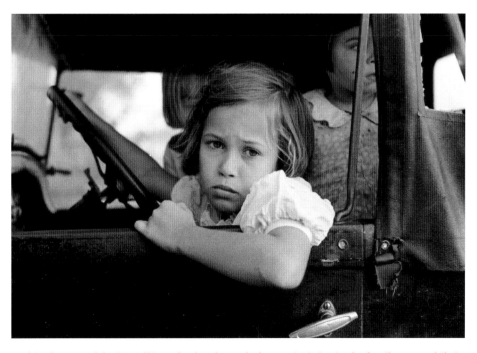

In this photograph by Russell Lee, the daughter of a farmer is sitting in the family automobile in November 1938. The crestfallen girl is waiting for her father to come out of the general store in Jarreau, Louisiana. It's hard to tell if she's bored or hungry—probably both. [*Library of Congress*]

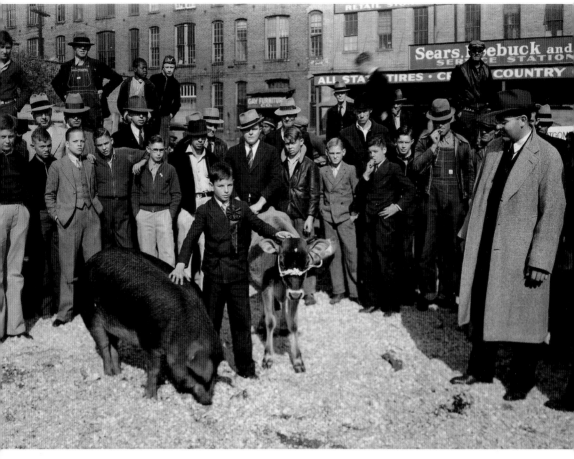

Grocery stores often held competitions as publicity events. In this case, an earnest young man was the grand prize winner at the second annual "Sears' Cow-Hog-Hen Project" in November 1938. He is standing with his surprisingly well-behaved hog and calf in front of the store in Montgomery. Contestants came from Montgomery, Autauga, Elmore, and Lowndes Counties. [*Alabama Archives*]

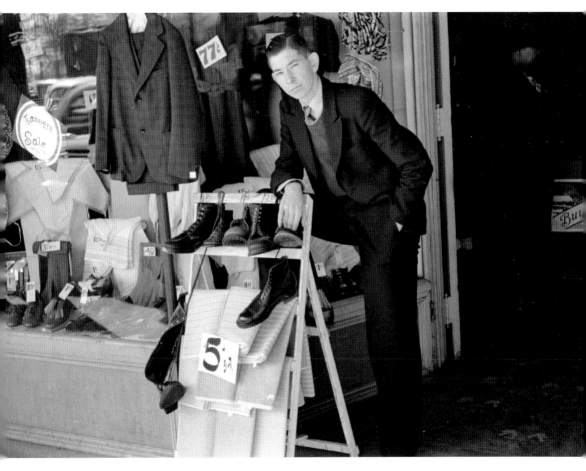

As towns grew, general stores became groceries while drugstores and department stores sprang up on main street. In January 1939, Russell Lee photographed this salesman with hair slicked down and dressed to the nines. The young man is standing in front of a clothing store on a Saturday afternoon in Laurel, Mississippi. [*Library of Congress*]

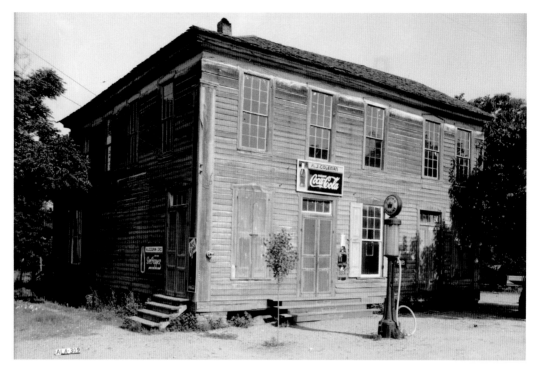

This general store was located at the intersection of State Highways 14 & 86 in Pickensville, Pickens County, Alabama. This photograph was made for the Historic American Buildings Survey, after 1933. The building may not look like a typical country store, but it does have a lone gas pump, and the mandatory Coca Cola signs. [*Library of Congress*]

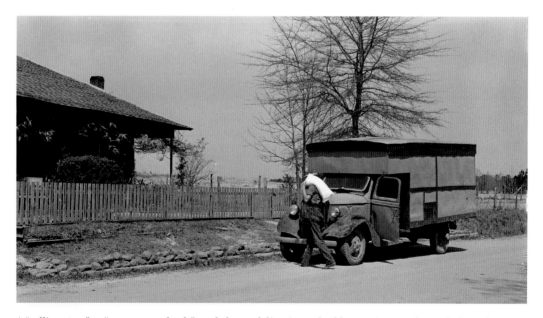

A "rolling store" or "grocery on wheels" made home deliveries and sold groceries out of a truck along the edge of the farm fields in the area. Here, a worker is carrying a sack of flour into a home out in the country. Marion Post Wolcott took this photograph in Coffee County, Alabama, in April 1939. [*Library of Congress*]

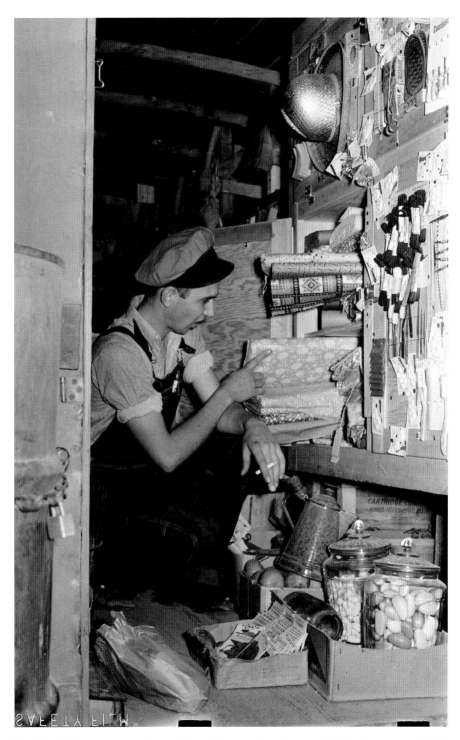

In this rolling store, a worker pulls out dry goods and groceries for farmers and field hands. There is also a tank of kerosene on the left. Daily sales averaged sixty dollars and the storekeeper took in lots of produce in trade. Marion Post Wolcott made this photograph in April 1939 in Coffee County, Alabama. [*Library of Congress*]

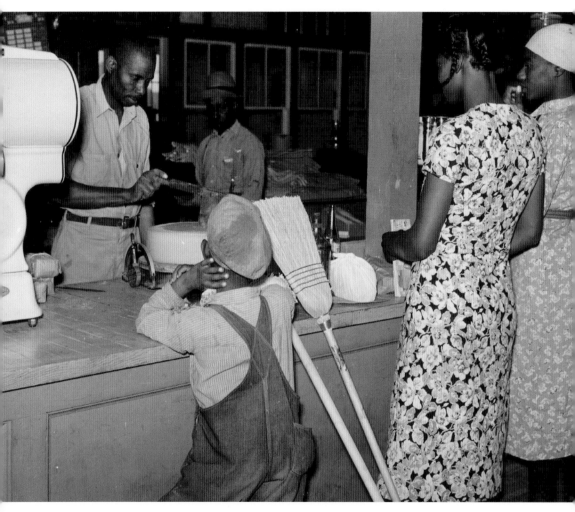

These two ladies are standing by the counter purchasing merchandise and groceries at the general store in Gee's Bend, Alabama. The storekeeper is cutting a wedge from a wheel of cheese and the young man is either accompanying the women or waiting his turn. Marion Post Wolcott photographed them in May 1939. [*Library of Congress*]

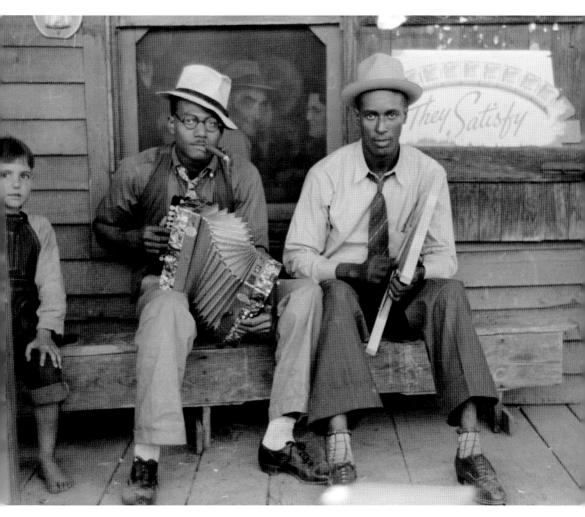

With a boy and others looking on and listening in, these two musicians are playing the accordion and washboard on the porch on the front of the country store near New Iberia, Louisiana. Russell Lee photographed the two men, who appear to be talented musicians and the best of pals in November 1938. [*Library of Congress*]

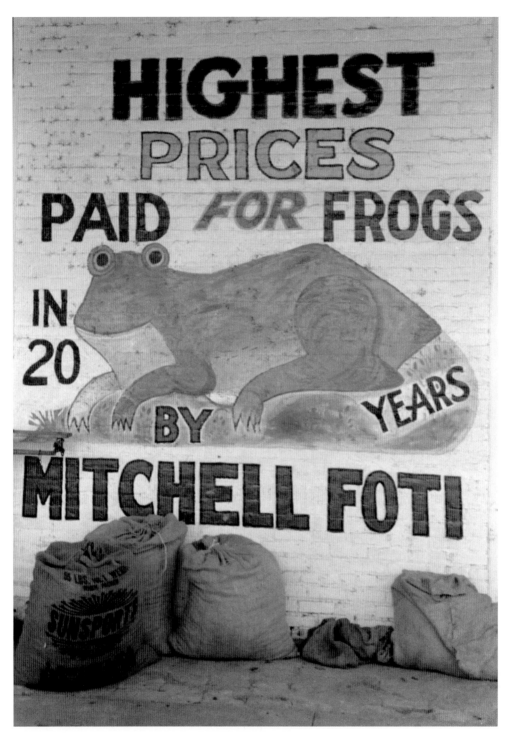

This sign in front of the country store in Saint Martinville, Louisiana, promises the highest prices paid for frogs, which was welcome income for Cajun hunters and fishermen in the bayous. In November 1938, Russell Lee photographed the sign, which includes a curious illustration of a happy bullfrog. [*Library of Congress*]

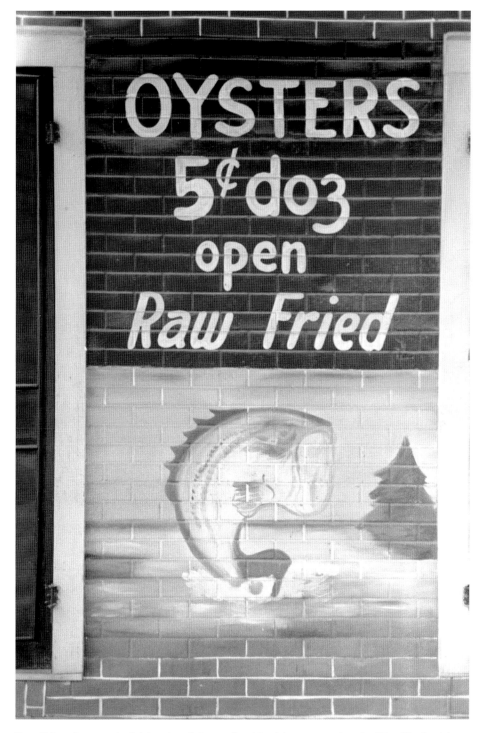

Russell Lee photographed this painted sign on the side of the country store in Abbeville, Louisiana, in November 1938. The sign is artfully made—both the illustration and the lettering. And prices can't be beat. Five cents for a dozen oysters was a deal, even in the Depression. [*Library of Congress*]

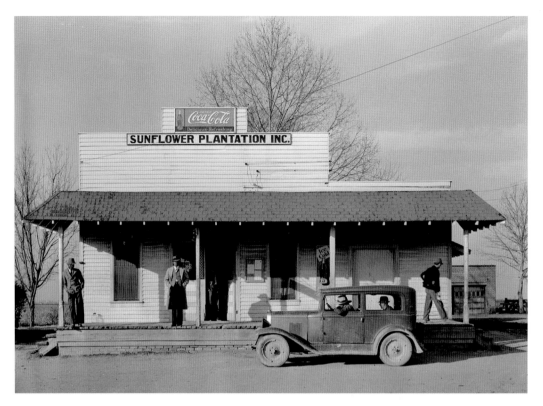

Russell Lee photographed the general store on Sunflower Plantation near Merigold, Bolivar County, Mississippi, in January 1939. Like Lee's other work, the image is artfully composed. A car has parked in front of the store, while one customer is headed home on foot and others linger on the porch. [*Library of Congress*]

Opposite page:

Above: Photographed by Russell Lee in January 1939, these African-American men are standing at the counter of the general store in Transylvania, East Carroll Parish, Louisiana. The men are enjoying their time off work, visiting friends and sharing the local news. [*Library of Congress*]

Below: These African-American men are standing in front of the general store in Mound Bayou, Mississippi. One is enjoying his pipe and all the men stared back at Walker Evans as he took this photograph in January 1939. A hint of suspicion is to be expected in the eyes of people who have borne so many hardships. [*Library of Congress*]

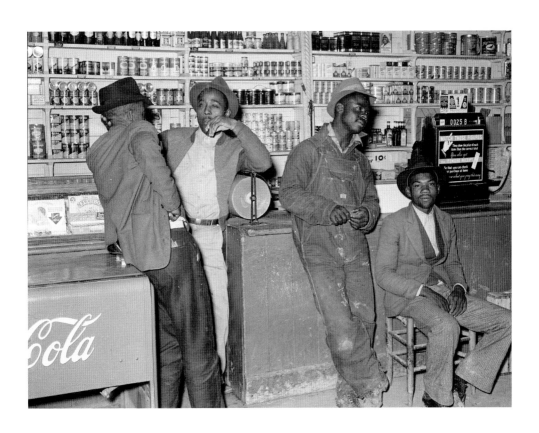

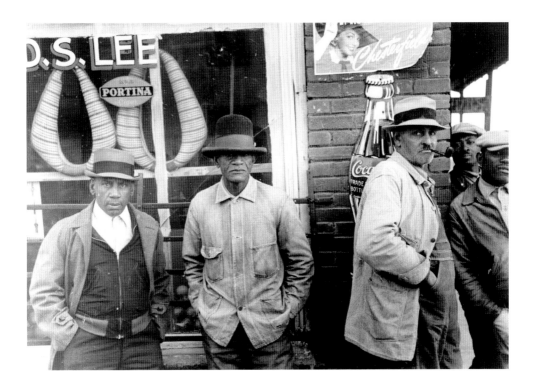

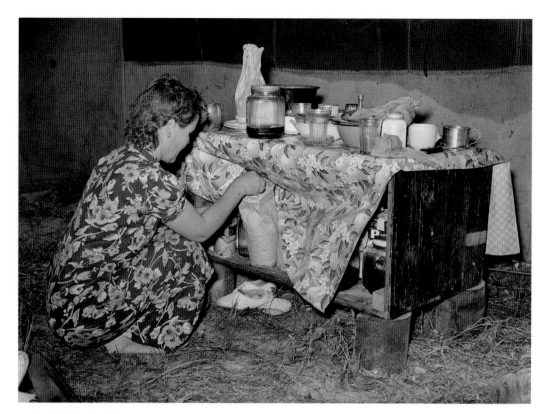

This migrant berry picker takes meager groceries from the "kitchen cabinet" in her tent near Hammond, Tangipahoa Parish, Louisiana. Although she and her husband work long days in the fields, stooped over to pick strawberries, they barely earn enough to feed their children. Russell Lee took her photograph in April 1939. [*Library of Congress*]

Opposite page:

Above: Outside the country store at Gees Bend, Alabama, these men are visiting by a wagon pulled by two sturdy mules. After a week of hard work in the fields, it's good to visit with friends and family. Marion Post Wolcott took their photograph on a clear and sunny Saturday morning in May 1939. [*Library of Congress*]

Below: Outside the country store at Gees Bend, Alabama, this man, identified as Earl Lee Young, catches up on his sleep after a week of hard work in the fields. He is using a cloth sack of refined flour as a pillow. Marion Post Wolcott took this photograph on a pleasant Saturday morning in May 1939. [*Library of Congress*]

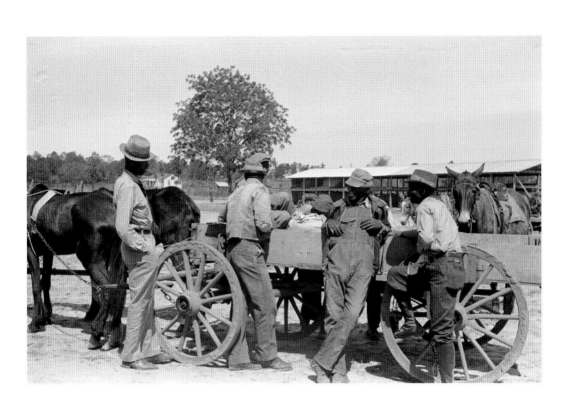

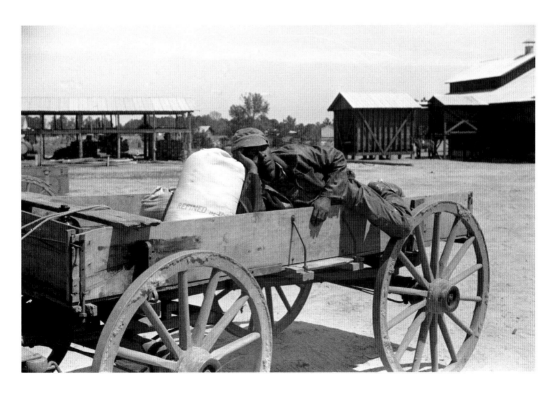

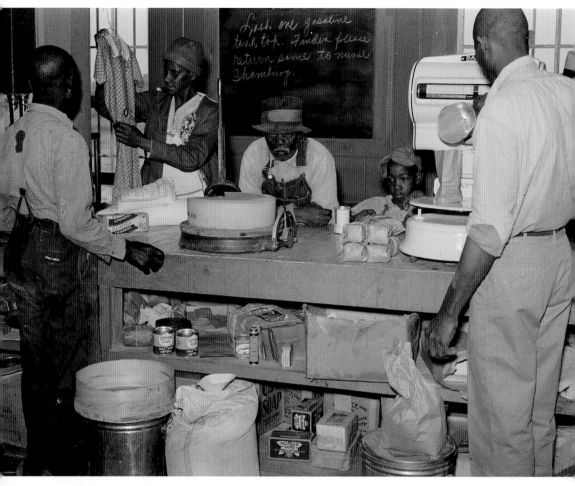

Inside the general store at Gee's Bend, Alabama, farmers and townspeople look over the groceries, staples, and merchandise in stock. The woman has her eye on a pretty dress. Likely, she hasn't gotten a store-bought dress for years, if ever. Marion Post Wolcott photographed her and others in the group in May 1939. [*Library of Congress*]

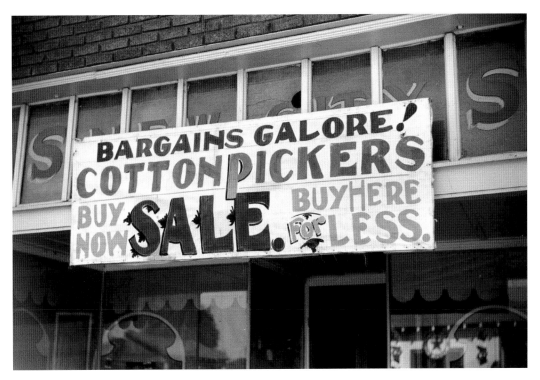

Marion Post Wolcott photographed this eye-catching sign around October 1939, in the small town of Merigold in the Mississippi Delta. Posted above the entrance to a general store, the sign promises "Sales Galore" and lower prices for cotton pickers, if you can believe what you read. [*Library of Congress*]

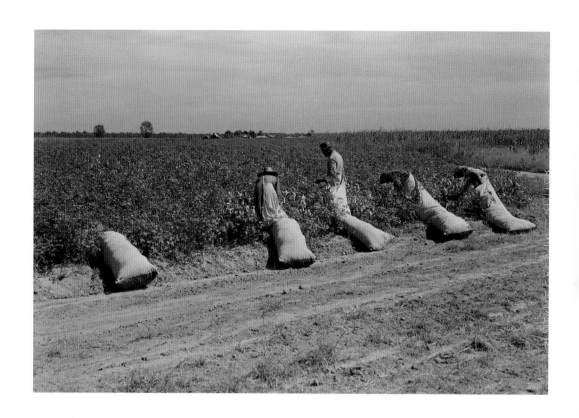

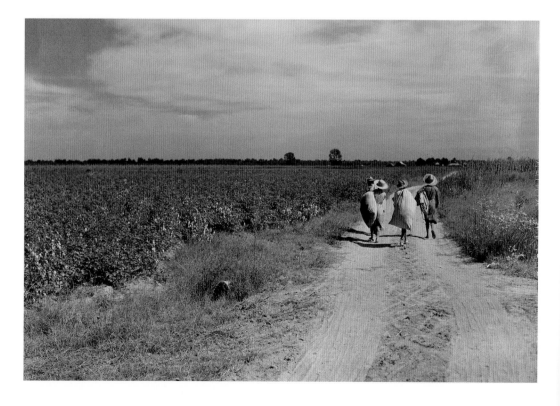

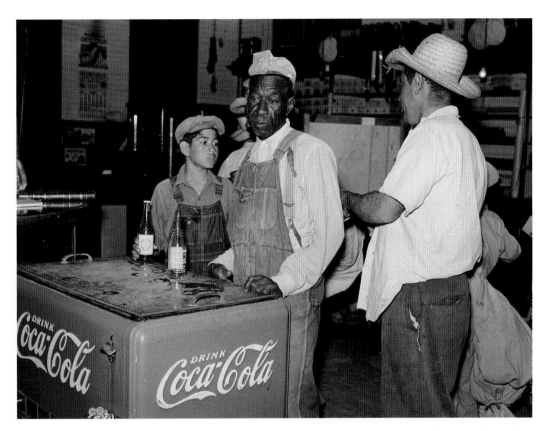

These Mexican and African-American cotton pickers have gathered in the store on Knowlton Plantation, Perthshire, Bolivar County, in the Mississippi Delta. The migrant workers are brought in from Texas every harvest season. Marion Post Wolcott photographed them at the end of another long day in October 1939. [*Library of Congress*]

Opposite page:

Above: Bags dragging behind them, these cotton pickers work their way up and down the rows on Mileston Plantation in the Mississippi Delta, Holmes County, Mississippi. Taken by Marion Post Wolcott in October 1939, the photograph documents the long, painstaking labor of picking each and every cotton boll by hand from dawn to dark. [*Library of Congress*]

Below: These African-American cotton pickers walk down a dusty road with bags of cotton on their backs. They have been stooped over all day picking by hand on the Mileston Plantation in the Mississippi Delta, Holmes County, Mississippi. Marion Post Wolcott captured this moment in October 1939. [*Library of Congress*]

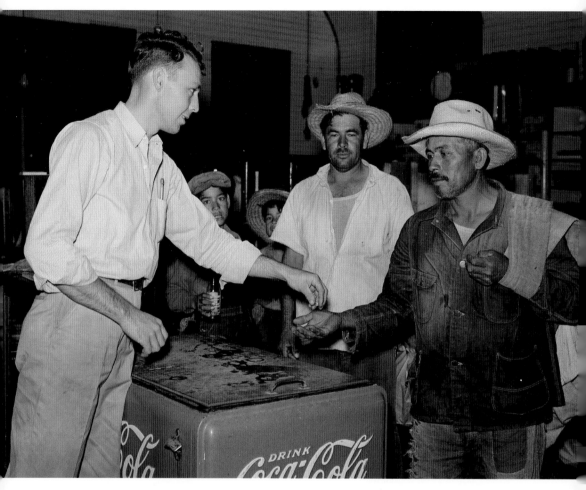

Marion Post Wolcott photographed the clerk and Mexican cotton pickers by the soda pop cooler in the store on the Knowlton Plantation, Perthshire, Bolivar County, Mississippi Delta in October 1939. The migrant workers and often their children were brought in trucks from Texas each harvest season. [*Library of Congress*]

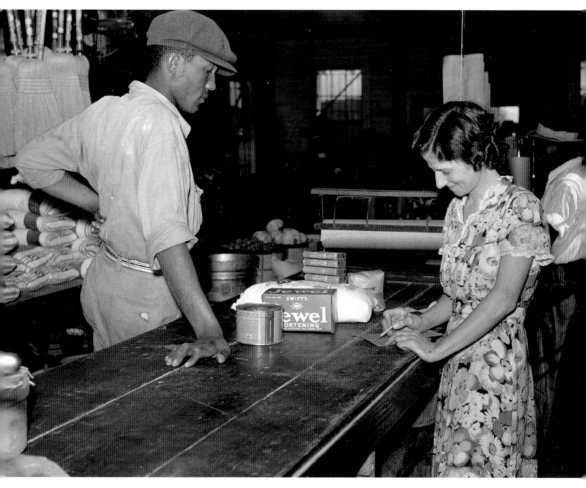

Marion Post Wolcott photographed this cotton picker purchasing groceries in the general store after he'd been paid his wages on a Saturday in November 1939. This store was located on the Mileston Plantation, Holmes County, in the cotton country of the Mississippi Delta. [*Library of Congress*]

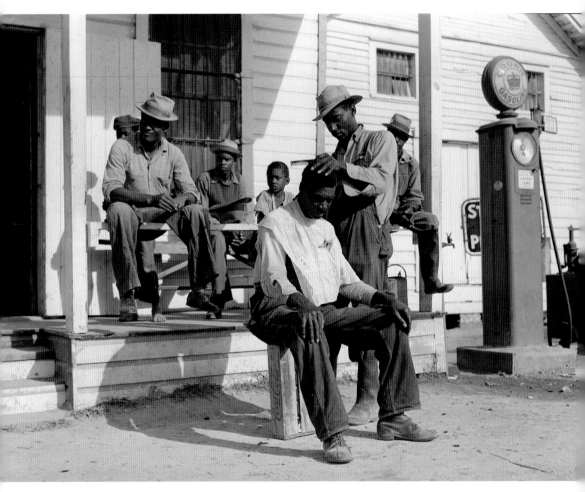

After getting paid on a Saturday in November 1939, these men relaxed and cut each other's hair in front of the plantation store at the Mileston Plantation, Holmes County, in the Mississippi Delta. Marion Post Wolcott captured this moment of leisure after a long week in the fields. [*Library of Congress*]

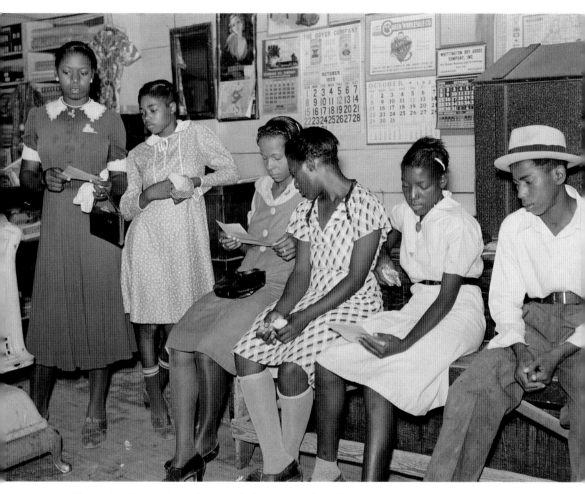

In this Marion Post Wolcott photograph from November 1939, these young African-American cotton pickers help each other read their mail at the post office in the Mileston Plantation store, Holmes County, in the Mississippi Delta. Often far from home, the migrant workers looked forward to the letters they have received from loved ones. [*Library of Congress*]

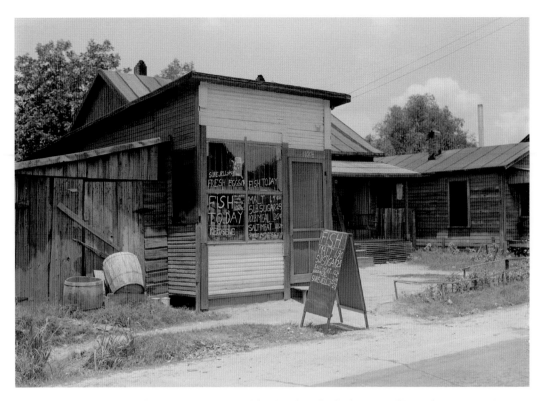

This grocery store in an African-American neighborhood in the little town of Laurel, Mississippi, carried a variety of foods, ranging from canned goods to sweet potatoes. In May 1939, when Marion Post Wolcott took this photograph, the signs at the store made it abundantly clear that customers could get "Fish Today." [*Library of Congress*]

Opposite page:

Above: Photographed by Marion Post Wolcott in October 1939, these men are enjoying a pleasant afternoon, playing both dominoes and cards in the shade. They are seated on soda fountain chairs in front of the drugstore and next to the general store in the heart of a small town, deep in the Mississippi Delta. [*Library of Congress*]

Below: Playing dominoes, cards, and perhaps other table games, these men are seated in soda fountain chairs. They are enjoying an afternoon in the shade along the main street in a small town in the Mississippi Delta, Mississippi. Marion Post Wolcott took their photograph in October 1939. [*Library of Congress*]

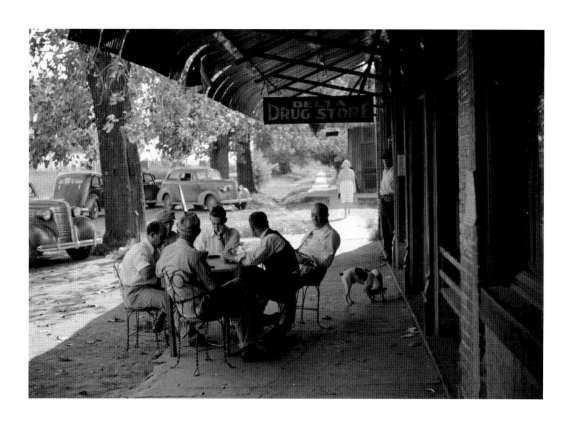

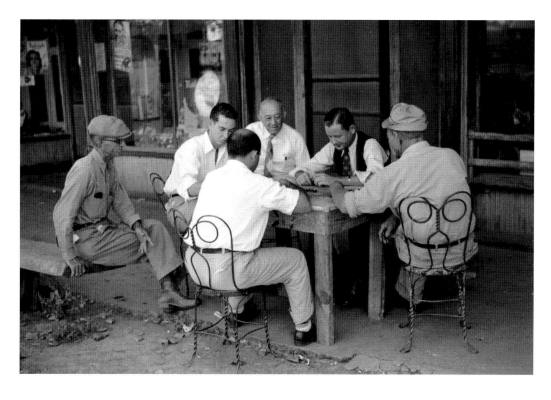

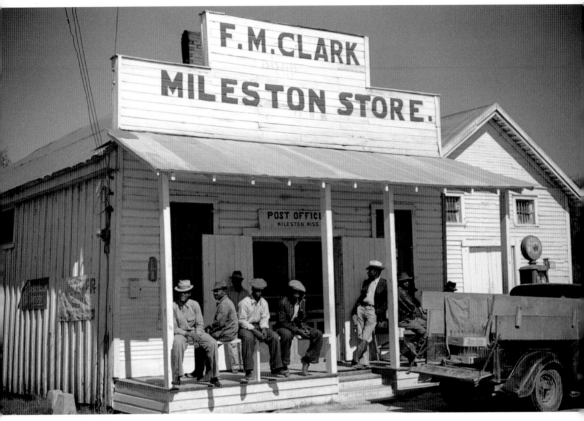

These farm tenants are hanging out on the porch of the cotton plantation store and Post Office at Mileston, Mississippi Delta. Marion Post Wolcott photographed the men relaxing (most likely on Sunday) and enjoying some companionship on a sunny day in October 1939. [*Library of Congress*]

3

REMEMBERING OLD PLACES

When America and its allies won World War II, young men and women came home to family farms and city streets throughout the Deep South. Young couples married and raised families. Much was familiar. It was the end of long years of depression and war. Many people once again enjoyed peace and prosperity. However, many also came home to poverty and a scarcity of jobs, and those jobs barely paid a living wage. The soldiers and sailors who were victorious in a world war could not find work back home. People moved away to jobs in Chicago, Detroit, and other Northern cities where industries were flourishing. Racism also drove thousands of African Americans North in a second wave of the "Great Migration."

Others remained. Here they had family and friends. It was home. Here they shopped at the old store and always had time to "visit a while." Storekeepers hung on as grocery chains overtook the small enterprises in neighborhoods and along country roads. Once a gathering place for people, these stores closed, one after another. After the Depression, the "New South" brought prosperity to the region, but not to small markets, which closed one after another. Often stores remained because people simply cherished their local market. For others they were the only "going concern" in the vicinity. The stores were certainly the only gathering place where folks could swap stories about the "old days." These little enterprises have a colorful past. Hopefully, they will persevere long into the future for our children and their children.

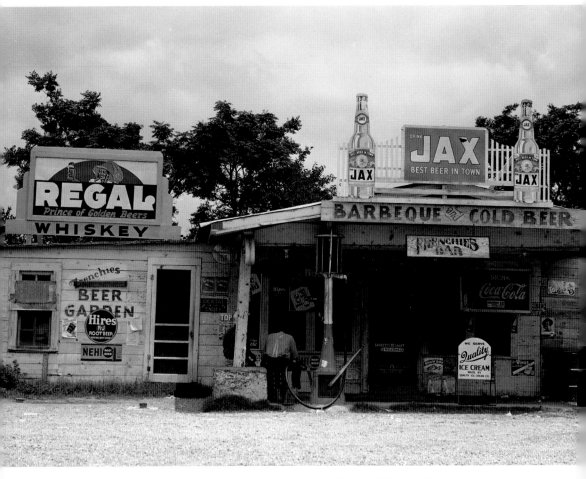

This enterprise at a crossroads in cotton country of the small town of Melrose, Natchitoches Parish, Louisiana, served many purposes: country store, Frenchie's bar, "jook" (juke) joint, "beer garden," and gas station. Marion Post Wolcott made this photograph on a quiet day in June 1940. [*Library of Congress*]

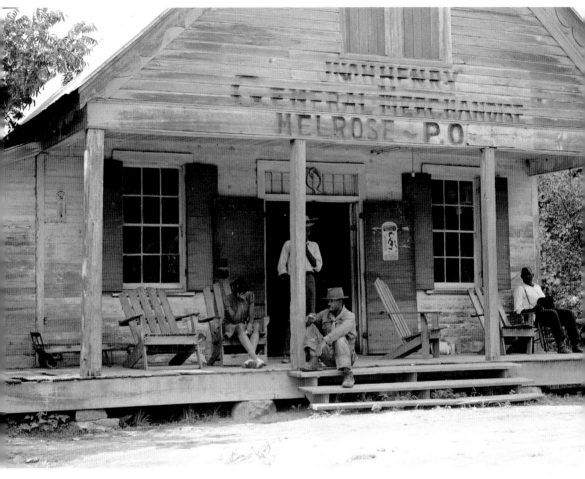

In June 1940, Marion Post Wolcott took this photograph at the John Henry store known after the plantation on which it was situated. Several men have gathered on the porch of the store and post office, which was located in Melrose, Natchitoches Parish, Louisiana. [*Library of Congress*]

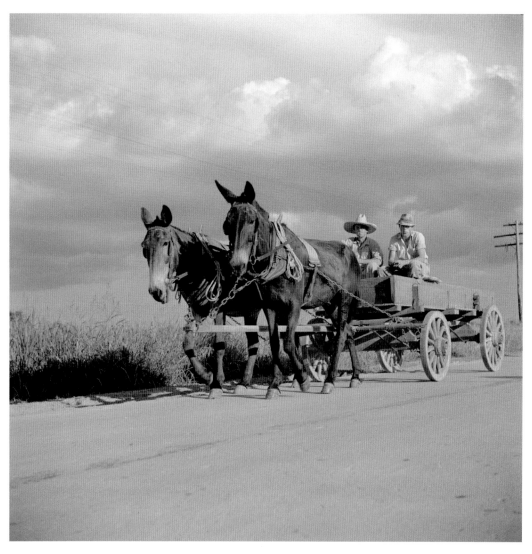

These two farmers are traveling along a dusty road to the general store in Transylvania, East Carroll Parish, Louisiana, on a clear day in June 1940. Marion Post Wolcott photographed the men sitting on the bench seat of a wagon pulled by a pair of finely matched mules. [*Library of Congress*]

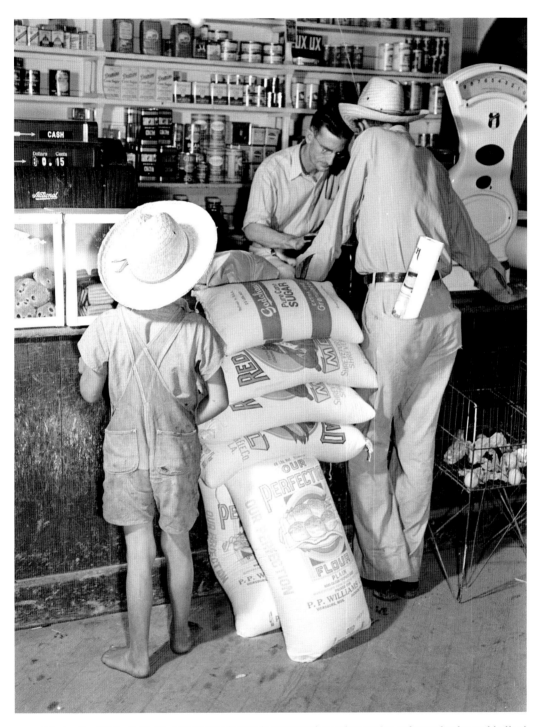

Marion Post Wolcott photographed this farmer buying staples and groceries, at least what he could afford for his family. He and his daughter are standing at the counter of the general store in Transylvania, East Carroll Parish, Louisiana. It was June 1940 and people were still struggling to get by in the Great Depression. [*Library of Congress*]

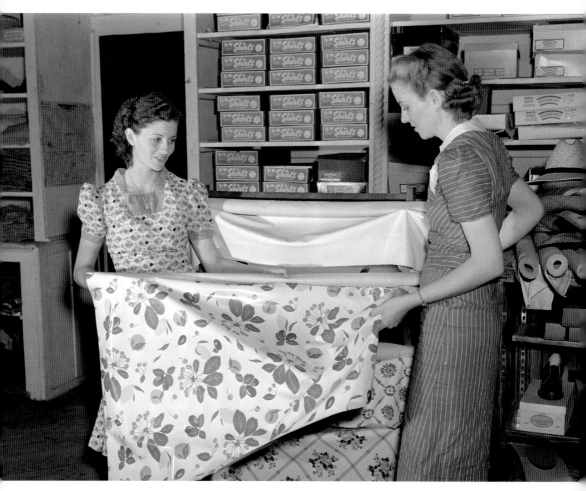

Marion Post Wolcott photographed this woman purchasing linoleum for her home with the assistance of the clerk at the general store in Transylvania, East Carroll Parish, Louisiana, in June 1940. The farmwife studies the patterns in stock at the store. She knows what she'd like, but it still costs cash money. [*Library of Congress*]

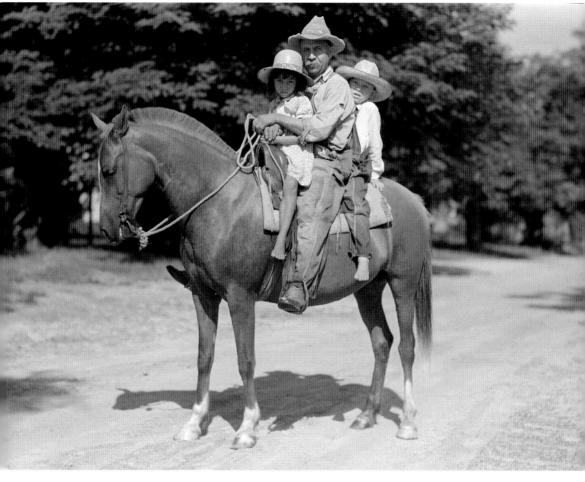

This farmer is ambling along on horseback with his grandchildren to buy staples from the general store at the crossroads in Melrose, Natchitoches Parish, Louisiana. Marion Post Wolcott took this touching photograph of the old and young traveling together in cotton country in June 1940. [*Library of Congress*]

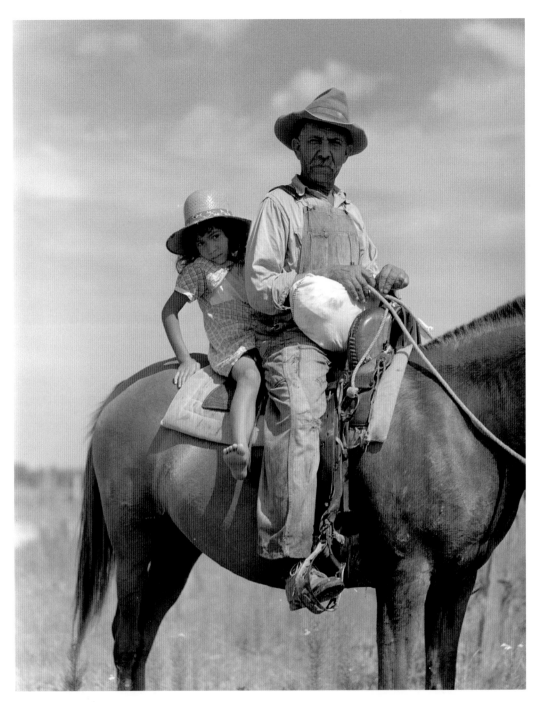

This farmer is riding home on horseback with his granddaughter after buying staples from the general store at the crossroads in Melrose, Natchitoches Parish, Louisiana. Marion Post Wolcott took this sweet photograph of the old and young riding together in June 1940. [*Library of Congress*]

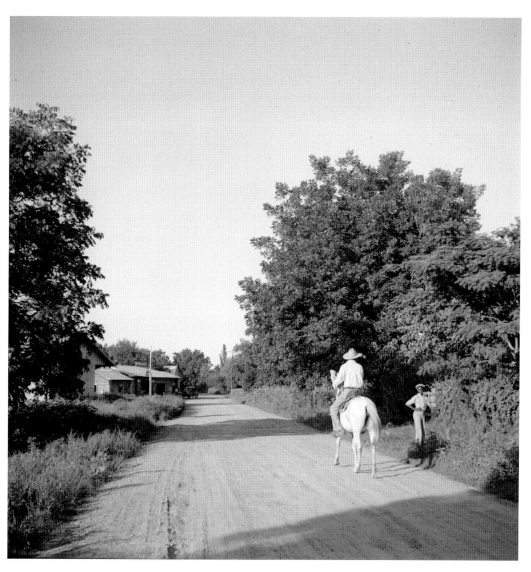

It is late in the day and the shadows are long as this farmer rides down a country road. He is returning home after buying staples and supplies at the country store at Melrose, Natchitoches Parish, Louisiana. Marion Post Wolcott photographed this quiet moment in June 1940. [*Library of Congress*]

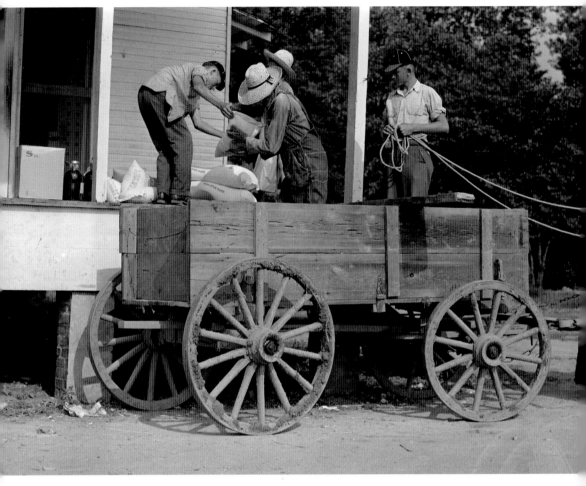

This farmer and his sturdy sons load their wagon with staples and supplies at the country store in Transylvania, East Carroll Parish, Louisiana. Marion Post Wolcott took their photograph in June 1940. It is the end of the day and they have to make the long trip back to the farm, but the men appear to be up to the job. [*Library of Congress*]

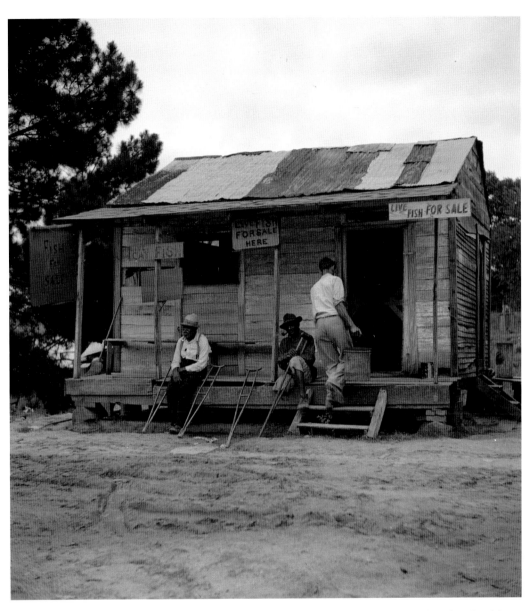

Marion Post Wolcott photographed this general store in the countryside near Natchitoches, Louisiana, in July 1940. If the signs are to be believed, this store offers "Live Fish," including "Cat Fish." A young man is carrying a bucket into the store while two old men with crutches sit on the edge of the porch. [*Library of Congress*]

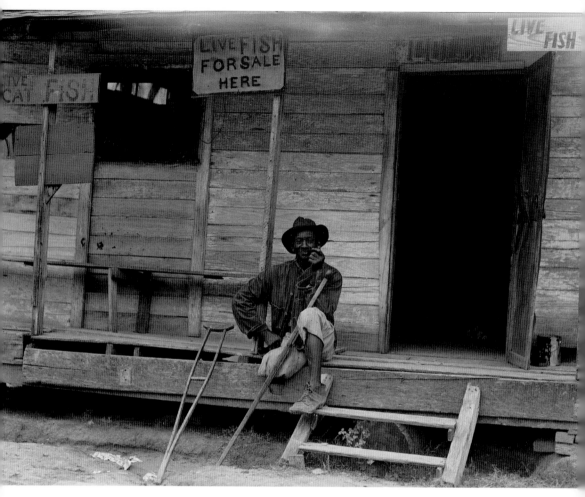

In June 1940, Marion Post Wolcott photographed this old man sitting on the porch of a country store where live fish are apparently for sale. His shoes are nearly worn through and he relies on a pair of wooden crutches to get around, mostly likely to the store and back home. [*Library of Congress*]

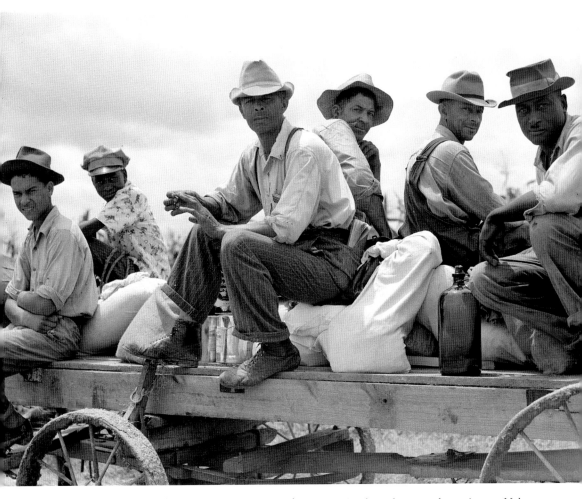

This group of farmers (tenants and sharecroppers) are returning from the general store in near Melrose, Natchitoches Parish, Louisiana, with groceries and other staples. Marion Post Wolcott photographed the men riding together in a farm wagon in July 1940. [*Library of Congress*]

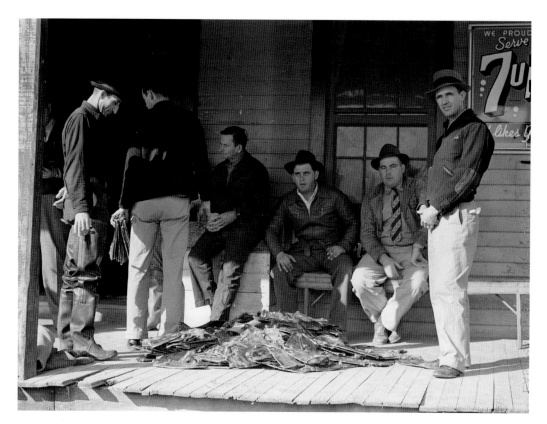

Spanish trappers—descendants of Islenos (Islanders) who migrated to Delacroix Island, Saint Bernard Parish, Louisiana—and fur buyers wait with piles of muskrat pelts. The dried pelts will be graded and sold at auction on the porch of the country store in St. Bernard. Marion Post Wolcott photographed the men in January 1941. [*Library of Congress*]

Opposite page:

Above: An expert grades muskrat pelts brought in from the wetlands of Delacroix Island while fur buyers and trappers look on during the auction sale on the porch of the country store in St. Bernard, Louisiana. Marion Post Wolcott took their photograph in January 1941. [*Library of Congress*]

Below: Fur buyers and trappers look on as an expert grades muskrat pelts that have been spread out during an auction sale on the porch of the country store in St. Bernard, Louisiana. If they make enough money, the trappers will buy staples at the store and go home the way they came—by boat. Marion Post Wolcott took their photograph in January 1941. [*Library of Congress*]

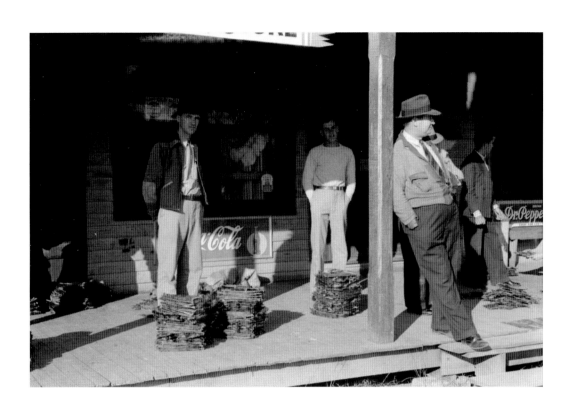

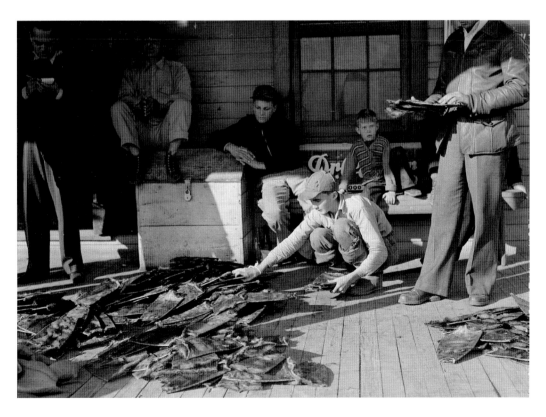

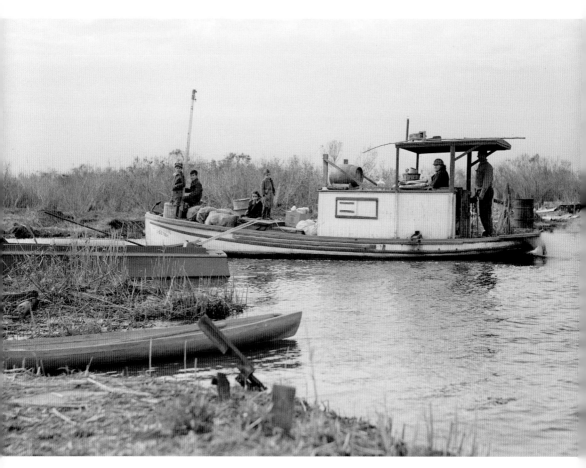

This Spanish trapper and his family are returning to Delacroix Island, Saint Bernard Parish, Louisiana, with groceries and supplies for their home in the swamp. They still have their muskrat pelts which they refused to sell because the fur buyers' prices were too low. Marion Post Wolcott photographed them in January 1941. [*Library of Congress*]

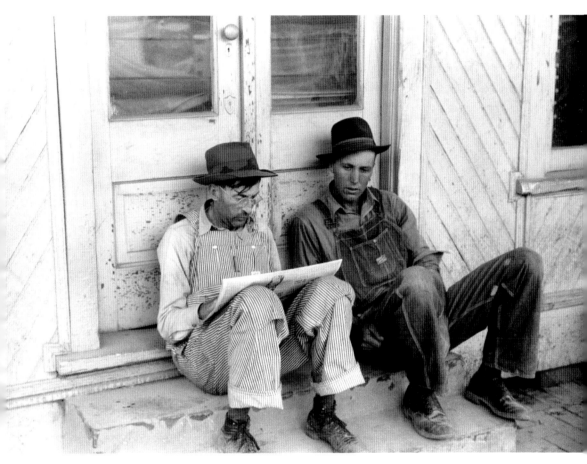

Seated on the stoop at the general store on the main street of the small town of Childersburg, Alabama, these farm workers are talking, probably about the weather and crop prices, and looking over the newspaper together. Jack Delano took this candid photograph of them in May 1941. [*Library of Congress*]

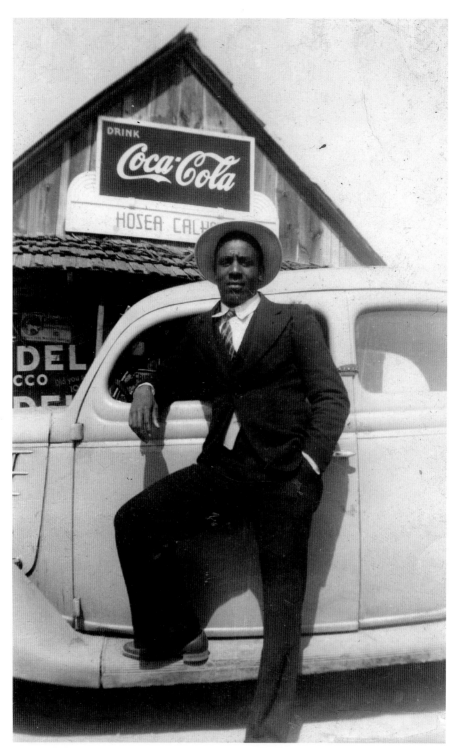

This man identified as Albert Datcher is standing by his shiny automobile in front of a country store sometime between 1940-1949. He's also all decked out and apparently ready for a night out on the town with that special someone. [*Alabama Archives*]

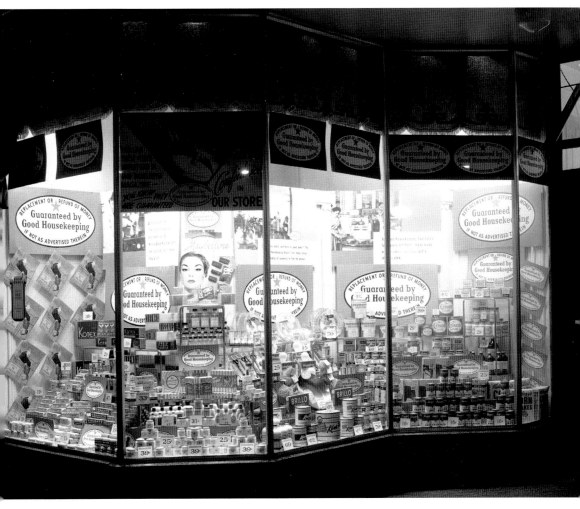

This appealing *Good Housekeeping* Week display was arranged in the front window at the Silver's store at 71-73 Dexter Avenue in Montgomery, Alabama. Photographed on February 1951, this popular store was owned by the H. L. Green Company. [*Alabama Department of Archives and History, 624 Washington Avenue, Montgomery, Alabama 36130*]

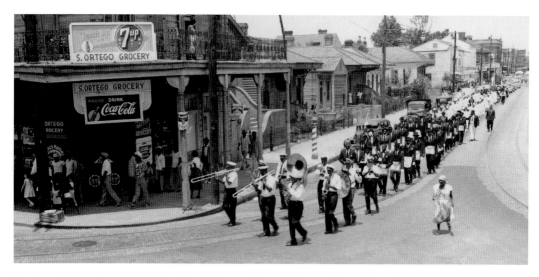

The Eureka Brass Band, including Albert Warner, "Sunny" Henry, Manuel Paul, Percy Humphrey, Red Clark, George "Kid Sheik" Colar, Reuben Roddy, Robert Lewis, and Willie Pajaud, parading and playing through New Orleans in 1952. Here, they are rounding the corner of Dryades and Philip Streets past the S. Ortego Grocery. [*Tulane University*]

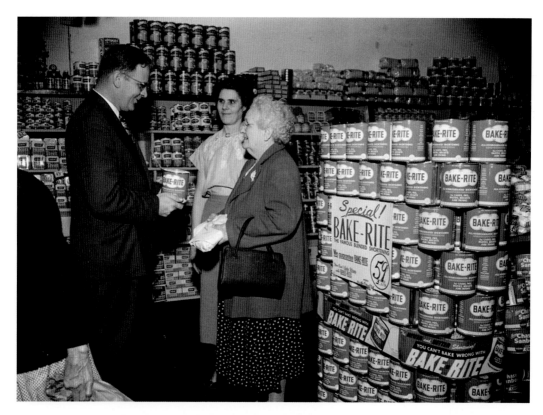

Taken by Robert C. Waller between 1947-1956, this photograph is of a promotional Bake-Rite shortening. It depicts a display and happy customers in the 11th Avenue in the 11th Avenue grocery on Hardy Street in Hattiesburg, Mississippi.

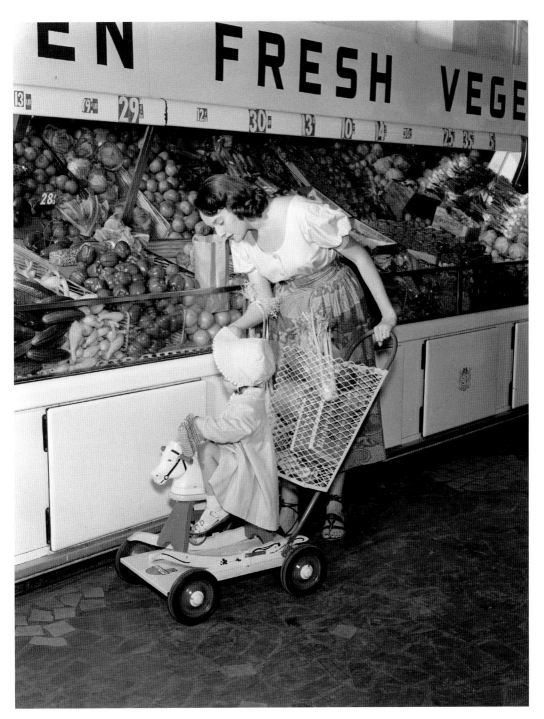

In a local grocery store, a young woman pushes a little girl on a horse stroller made by the Jackson Manufacturing Company in Montgomery, Alabama. The nifty basket is detachable, and the horse is quite the wild bronco, as shown in this photograph taken by John E. Scott on April 17, 1953. [*Alabama Archives*]

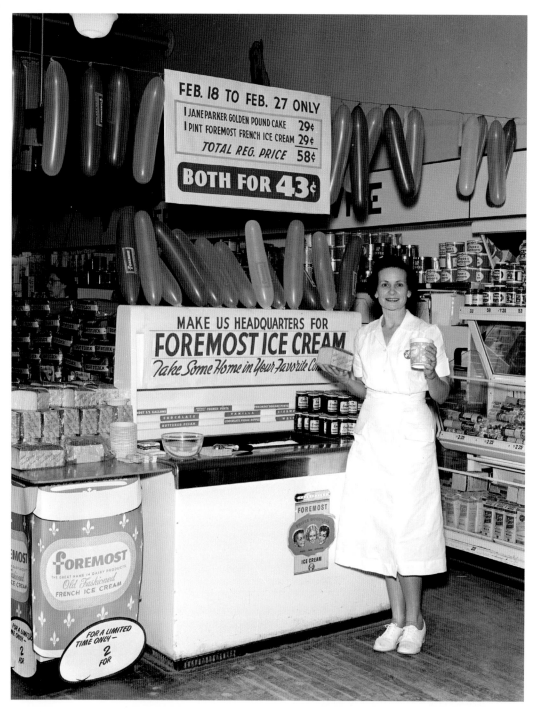

This display advertises a discount on the purchase of a Jane Parker pound cake and a pint of Foremost French ice cream. (Foremost later became Farmbest). A woman is also offering samples. The photograph was taken by John E. Scott on February 25, 1954, in an A & P grocery in Montgomery, Alabama. [*Alabama Archives*]

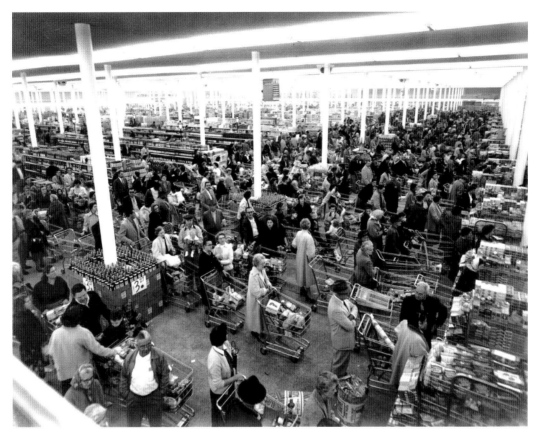

Here is a birds-eye view of the opening day (November 25, 1957) in a new Gentilly Store owned and operated by Schwegmann Brothers Super Markets. About fifteen checkout counters are open, all with long lines keeping the cashiers busy. The new store appears to be quite a hit with local people. [*Historic New Orleans Collection*]

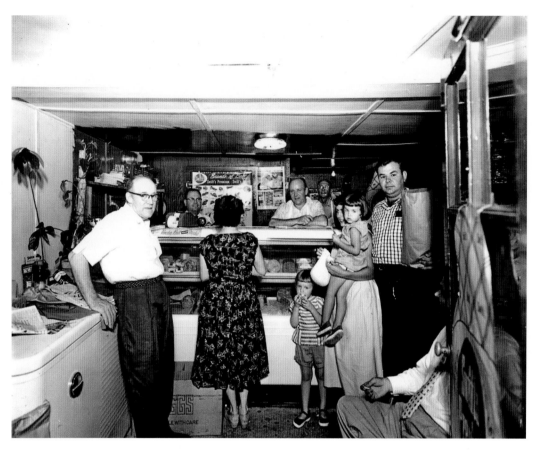

This view of Lee's Meat Market on Central Avenue in Jefferson Parish shows several men working behind the glass case, families with groceries, and a man sitting in a chair. Taken on July 28, 1958, the photograph is a charming glimpse of life in small, family-run, neighborhood markets in Louisiana. [*Historic New Orleans Collection*]

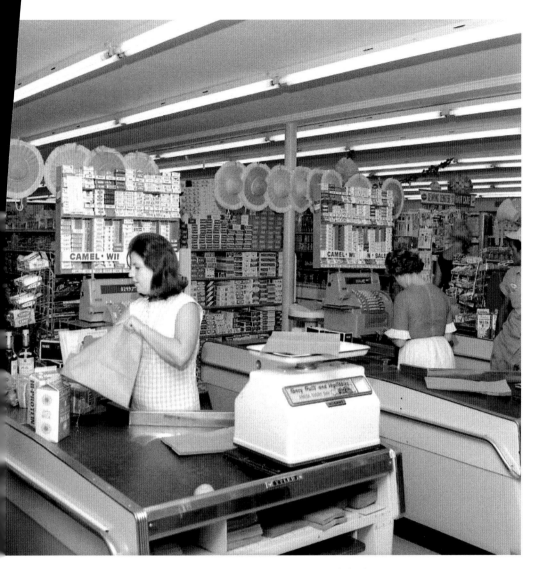

Two young women are efficiently handling the cash register and checkout counter at a grocery store in Grand Isle, Jefferson Parish, Louisiana. Bob Bigelow photographed the cashiers in the 1960s, probably the early years of the decade. [*State Library of Louisiana Historic Photograph Collection*]

ABOUT THE AUTHOR

RAYMOND BIAL (pronounced "beal") has been taking photographs and creating books for nearly fifty years. To date, he has published more than 100 books for children and adults. Raymond's most recent books include *The Shaker Village*, a lovely collection of color photographs depicting the simplicity and grace of this remarkable community. He has also published several works of fiction, including *Chigger*, a touching and humorous novel, and several scary mysteries and collections of ghost stories. Among his most popular books over the years have been *Where Lincoln Walked* and *The Underground Railroad*.